FOR ALL
AND FOR ALL THIS
MERRY CHRISTMAS DAD!!

Lillian Alling

THE JOURNEY HOME

Lillian Alling

THE JOURNEY HOME

SUSAN SMITH-JOSEPHY

 CAITLIN PRESS

Caitlin Press Inc.
8100 Alderwood Road,
Halfmoon Bay, BC V0N 1Y1
www.caitlin-press.com

Edited by Jane Stevenson and Betty Keller
Text and cover design by Vici Johnstone, maps by Kathleen Fraser
Illustrations by Eric Josephy
Front cover image: Detail of White Pass Dawson City Museum 1982. 202.2
Front cover image of Lillian Alling: Detail of image from Atlin Historical Society, see page 122
Printed in Canada

Caitlin Press Inc. acknowledges financial support from the Government of Canada through the Canada Book Fund and the Canada Council for the Arts, and from the Province of British Columbia through the British Columbia Arts Council and the Book Publisher's Tax Credit.

Canada Council Conseil des Arts
for the Arts du Canada

BRITISH COLUMBIA
ARTS COUNCIL

Library and Archives Canada Cataloguing in Publication
Smith-Josephy, Susan
 Lillian Alling: the journey home/Susan Smith-Josephy.

Includes bibliographical references.
ISBN 978-1-894759-54-0

 1. Alling, Lillian—Travel. 2. British Columbia—Description
and travel. 3. Yukon—Description and travel. 4. Alaska—
Description and travel. 5. Women travellers—Biography.
6. Women adventurers—Biography. I. Title.

FC3817.3.S65 2011 910.82 C2011-904938-4

For Lillian, of course.

Contents

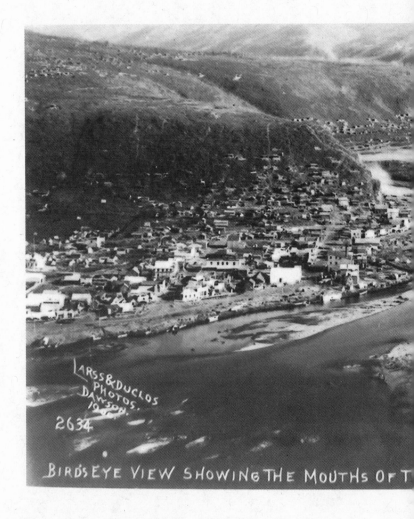

Bird's-eye view of South Dawson, c. 1900. DAWSON CITY MUSEUM
1983.181.3.47, LARRS & DUCLOS PHOTOS

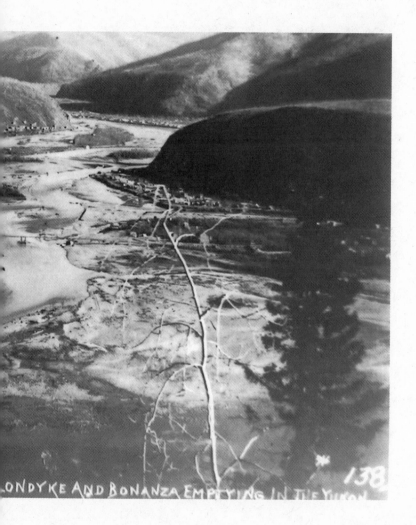

LONDYKE AND BONANZA EMPTYING IN THE YUKON

138

Thomas Gulch. DAWSON CITY MUSEUM 1981.58.1.138

Preface

*L*illian Alling was a remarkable woman and her adventures intrigued me from the first moment I heard about her. However, I never meant to write a book about her.

I first became interested in Lillian when I read a small blurb about her in our local historical society's newsletter. Her story seemed preposterous: there was no way a woman could have walked from New York to Siberia. So I did some idle research online and found a few websites. Read some library books. Found some mentions of her in anthologies of women adventurers and volumes about eccentrics. I started making photocopies of the articles I found and checked every reference in every article. Soon I had a two-foot-high stack of paper. I also kept a record of everything on my computer. I told friends about my

interest in Lillian, and people started emailing me with more articles and names of people to contact. Finally I put up a website, www.lillianalling.ca, to announce my intention of writing a book. This generated more emails and more letters.

I kept writing to museums, archives and authors who'd written about Lillian and to anyone else who might be interested. I bombarded the local library with inter-library loan requests for related works on the history of the places that she visited and the people with whom she came in contact. I met, via email and letters, people who were experts on trails and trekking, the 1920s, the British Columbia Provincial Police force and so much more. Other writers who had done some research on Lillian mailed me either their manuscripts or their piles of research articles—or both. I contacted descendants of some of the key people whom she had met on her journey, and I was thrilled to learn that they had been told stories about her. These people were kind enough to allow me to interview them, and they supplied photos of the ancestors who had told them the stories. I travelled a portion of Lillian's route in British Columbia, particularly the Pine Pass area and the road from Hyder and Stewart to Hazelton and Smithers, and took the ferry to Prince Rupert.

And just as the telegraph and other new technologies helped Lillian to travel such long distances and to have her story precede her wherever she went as she crossed Canada and entered Alaska, even newer technologies helped me to find her again more than eighty years later. While this book represents three years of research and writing, without the Internet, it would have taken many more years and dollars and would not have been as comprehensive. Of course, online research is not a substitute for visiting people and places, but Lillian's journey was so long ago and crossed such a vast area that corresponding via email with people in the places she travelled through seemed like the obvious choice.

Sometimes I was lucky enough to find relevant travel journals or newspaper articles that had first-hand information about Lillian and her trek. At other times I followed clues and leads from secondary sources and articles. I figured out her route by going over old documents, and I wrote to small-town museums and archives along that route to see if they had any new information. Often they didn't. Sometimes they came up trumps, digging into their old files, copying photos for me, and cheering me on through emails and letters.

Some people have called Lillian Alling crazy, but I came to love Lillian Alling, the eccentric.

I came to know a woman who had drive and courage and single-mindedness. She was a loner and an independent thinker who didn't like crowds too much, but preferred the wide-open spaces where she could be free and be herself. She was reserved but readily accepted help and was cooperative with authorities. Although she appears to have had quite a temper when she was under pressure, she seems to have stoically tolerated being cornered by people or forced indoors by the weather or institutionalized because she knew she would soon be on her own and outdoors again. To me, she seems to have been a reasonable human being on a very difficult quest.

Lillian Alling's tale has been fictionalized a number of times, probably because her spirit resonates with the romantic in all of us. She has been the subject of at least two novels. She inspired Amy Bloom's *Away*, though the author is skeptical of the real Lillian's existence, and Canadian writer Sherry Coffey is turning her MFA thesis into a book about her. Additionally, her life has been covered in the graphic novel *Lillian the Legend* by Kerry Byrne and in the play *All the Way to Russia With Love* by Susan M. Fleming, which was staged at the Ottawa Fringe Festival. Ted Eames has written an epic poem about her. A film about Lillian by Daniel Janke of

Northern Town Films may be underway. A 1994 French film, *La piste du télégraphe* (The Telegraph Route) was written and directed by Liliane de Kermadec. In October 2010 the Vancouver Opera Company staged the Canadian debut of *Lillian Alling,* the opera, to critical acclaim. Most recently her story has been featured in a short skit by the Dawson Museum in the Yukon as part of their Lillian Alling display.

I share Lillian Alling's true story with you now in the hope that you will enjoy reading about her. I also share it in the hope that someone, somewhere, holds the final clue that can help solve the mystery of what happened to Lillian Alling.

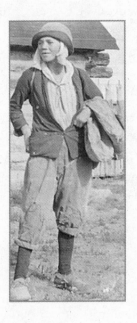

One of the two photos of Lillian taken by Marie Murphy in the summer of 1928. ATLIN MUSEUM & ARCHIVES

The Mystery of Lillian Alling's Origins

Most people living in North America today, with the exception of indigenous peoples, are immigrants or the descendants of immigrants. Many of us are familiar with the immigrant story: the push away from the old country as the result of economic pressures, social and political oppression or religious persecution and the trip across the Atlantic or Pacific fraught with dangers, discomfort, illness and sometimes death. In this myth, the huge step of leaving one's homeland then surviving the ordeal of an ocean crossing was rewarded by a tidy reception at some immigration depot like Ellis Island or perhaps Halifax's Pier 21. Then, once the individual was legitimized in the new country of choice, the heroic story culminated in the struggle to settle, raise a family, adapt and succeed. This is the successful North American dream.

Certainly this immigrant experience is usually painted as positive. But for some people, leaving home and facing the overwhelming challenges of a new country can become an intolerable situation from which they must escape. So what happens to those immigrants who do not succeed on the terms of the new country? What of the newcomers who just do not fit in, who reject the culture and mores of their new land? For them the dream has been rendered meaningless or has turned into a nightmare. They must either endure a life of misery in their adopted country or return home. Between 1908, when US immigration authorities began keeping records on departures, and 1920, three out of every eight immigrants returned home to their native lands. And by the Great Depression of the 1930s, more people were returning home than entering the country.[1]

… by the Great Depression of the 1930s, more people were returning home than entering the country.

From the few words Lillian Alling spoke on that subject, it appears that she had a hard time as an immigrant so she chose to return to Europe. Her drive to return home was not that unusual. It was the length and scope of her journey that were different than most. She chose to walk back to Europe and to minimize her

ocean crossing to the 50 miles (80 kilometres) between Alaska and Siberia. Did she really walk from New York to Alaska through Canada and eventually end up in Siberia? Yes, she did. Her story, in fact, spans the globe— from Europe, across the Atlantic, across the whole North American continent and then across the Bering Strait to Asia.

Improvements in transportation and communication made her journey possible. The popularity of motor vehicle travel had necessitated the construction of highways and roads. Railways had been built from coast to coast, and even though she never travelled by train as far as is known, the rail lines provided pathways where roads did not exist. The telegraph, and the telegraph lines in particular, gave her a trail to follow through the wilderness of northern British Columbia. But although it is known that she sometimes accepted a ride and she used boats where necessary, for the most part history has recorded that she made the entire trip using the oldest mode of transport: walking.

But the story of Lillian Alling's journey starts and ends with mysteries—both her origins and her fate are unknown. The woman known to history as Lillian Alling crossed from the state of New York into Canada at

Niagara Falls, Ontario, on Christmas Eve 1926. She was alone. It was raining that day but mild, the temperature just a little below zero. When the Customs official asked her the routine entry questions, she answered politely in English with an eastern European accent.

"Last place of residence?"

"Rochester, New York."

"What is your religion?"

"Catholic."

"Where were you born?"

"Poland."

According to the border crossing documentation, Lillian also stated that she had lived in Toronto from 1915 to 1921. She said she was thirty years old, married, and a housewife and that she planned to continue being a housewife upon arrival in Canada. Lillian may have meant "housekeeper," as she was travelling without a husband and had performed domestic work in New York. She said she could speak English and gave her destination as Niagara Falls, Ontario. (She didn't bother to mention that Niagara Falls was just the first stop on a journey across northern North America that would take her more than 6,000 miles (9,650 kilometres) and last almost three years.) She said she had no known relative

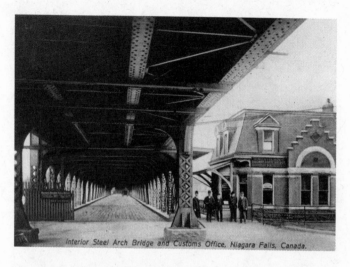

Interior Steel Arch Bridge and Customs Office, Niagara Falls, Canada.

Niagara Falls Custom House stands beside the Grand Trunk Railway Steel Arch Bridge, connecting Canada to the United States. PHOTO F.H. LESLIE, NIAGARA FALLS (ONTARIO) PUBLIC LIBRARY, D422628

or friend as her contact person in Canada. She also gave "none" as the answer to the name of her nearest relative. She was carrying twenty dollars with her.[2]

Although sometimes on her trek across the continent, Lillian Alling was referred to as Russian, she made it quite clear in her response to the Customs officer at Niagara Falls that she had been born in Poland. Some of the later confusion may have been due to the inability of Canadians to distinguish between a Polish and a Russian accent. However, this confusion also arose because

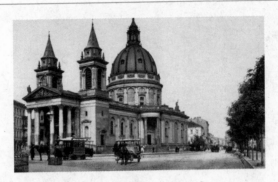

Warsaw, Poland, c. 1900. LIBRARY OF CONGRESS, PRINTS AND PHOTOGRAPHS DIVISION, PHOTO-CHROM PRINTS COLLECTION C–DIG–PPMSC–03918

Following the Congress of Vienna in 1815, most of Poland was partitioned and placed under the rule of Russia, Austria and Prussia, the exception being the city of Cracow, which became an independent republic. Eastern Poland became a sovereign state, called the Kingdom of Poland, but it was united with the Russian throne. Although this arrangement was the most liberal of all the partitions, by the end of the century repressive measures by the Russian monarchy had reduced it to nothing more than a puppet kingdom ruled by a governor general who maintained strict control of all military forces and judicial systems. The northwestern portion of Poland, which was awarded to Prussia, fared little better.

Constitutional rights guaranteed to the Polish people by the treaty were gradually eroded. German laws were introduced, the Polish language was no longer used by administrative bodies, and schools were taught by German teachers. Southern Poland, which included the kingdoms of Galicia and Lodomeria and New Galicia, was placed under the control of the Austro-Hungarian Empire. (In 1846 Austria also absorbed the independent republic of Cracow.) Although by the end of the century this area had gained more autonomy than those regions controlled by Russia and Prussia, it had few industries so it was the most economically challenged and had a 60 percent illiteracy rate.

The combination of political and social repression and poverty resulted in massive emigration from all three areas. Although those who came to Canada in the first migration wave were classified as Russians, Germans or Austrians, by 1901 they were being counted as Poles in the Canadian census, and their numbers rose from 6,285 in the 1901 census to 33,652 in 1911 to 53,403 in 1921; most were farmers and rural labourers who formed numerous small communities across the prairie provinces. After Poland was officially recognized as an independent

republic by the Treaty of Versailles in 1919, the national and ethnic identities of the Polish immigrants were more clearly defined, and while some of them still went to the prairie provinces, a greater number migrated to urban areas, especially Toronto.

Poland became an independent republic in 1919, but the Red Army of the new Soviet government of Russia continued an attempt to dominate the new republic, fighting its way almost to the outskirts of Warsaw. They were finally defeated by a Polish army under Marshal Jozef Pilsudski and an armistice was signed in October 1920. The country remained in economic and political disarray until 1926 when Pilsudski staged a military coup and became dictator of Poland, remaining in that role until his death in 1935. In 1939 the country was occupied by the armies of Nazi Germany.

from 1815 to 1919, Poland was divided between Prussia, Russia and Austria-Hungary, which resulted in Polish immigrants to Canada being categorized by early census takers as Russians, Germans or Austrians.

Prior to 1890 most of the Polish immigrants came from the Kashub region in north central Poland, and

they settled in Renfrew County, Ontario, but Poles from Galicia, in the South of Poland, arrived in far greater numbers between 1907 and 1914. As a result, most immigrants from eastern or central Europe were referred to as Galicians.[3] Many immigrants in this group found urban life more appealing than agricultural labour and moved their whole families to the towns. Thus, if Lillian came from the Kashub region, she might have immigrated with her parents as early as 1896 when she was an infant. However, since she spoke with a Polish accent and she said that she had lived in Toronto from 1915 to 1921 and she had no known relative or friend in Canada, she probably came by herself as a young adult in the later wave of immigration from Galicia.

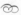

In the late nineteenth and early twentieth centuries the Canadian government kept no official records of people arriving in Canada from Europe. In fact, immigrants were not even required to apply to enter the country. Mary Munk of the Canadian Genealogy Centre, Client Services Division, Library and Archives Canada, explains:

> Immigrants from Europe would buy a ticket
> for a ship sailing to Canada. They would be
> seen by a medical examiner to make sure
> they didn't have any medical conditions such
> as blindness or tuberculosis. They did not

require a visa. If they had a passport, they
would have shown it upon boarding, but
the Canadian government did not keep
their passports.[4]

And according to the Library and Archives Canada website:

Passenger lists (RG 76) were the official
record of immigration during this period
… The [ship's passenger] lists contain
information such as name, age, country of
origin, occupation and intended destina-
tion. They are arranged by port and date
of arrival, with the exception of some
years between 1919 and 1924, when an
individual Form 30A was used … Many
immigrants to Canada came from the
United States or sailed from Europe to
American ports on their way to Canada.
Prior to April 1908, people were able to
move freely across the border from the
United States into Canada; no record of
immigration exists for those individuals.

Not all immigrants crossing the bor-
der were registered. Some crossed when
the ports were closed or where no port
existed. Many families were not registered

because one or both parents had been born in Canada or they had lived there before, and they were considered "returning Canadians" rather than immigrants.

No record of a Lillian Alling, born in Poland, has been found on any available passenger list for ships coming from Europe and landing in either Canada or the US between 1896, her birth year, and 1926 when she turned up at the Niagara Falls Customs office. However, passengers from mainland Europe usually made their way to Great Britain where they boarded transatlantic ships at ports such as Liverpool, London and Glasgow to land in New York, Halifax or Quebec City. My searches of various online databases that have passenger lists for ships that left the UK in the appropriate time period reveal some names close to Lillian Alling's but none are exactly the same.

Alling is not an unusual name. There are Allings in Estonia, England, Sweden, Denmark, Norway, Germany, the Netherlands, Switzerland and Austria. But it is certainly possible that Alling was not the name by which she was known in Poland; her name may have been anglicized to become Alling, either by her or by someone else, once she was in North America. In Poland her name may have been Oling, Aling, Eling, Ohling, Ehling or Ailing. Alling could also be a derivative of a Jewish name such as Olejnik, Olejnikov, Olejnikovskij, Olejskij,

Olekhnovich, Olen, Olender, Olnderov and Olenov. [5] It is also possible that it was her married name or it was not her name at all, and she simply "borrowed" it to hide her real identity.

Lillian told the Customs officer at Niagara Falls that she had lived in Toronto from 1915 to 1921, but a search of Ontario records revealed nothing conclusive. There were no Allings in the Toronto City directory for 1921 though there is one Lillian E. Allin—with no "g"—living at 1418 Gerard East. The name Lillian Gua appears on the 1911 Canadian census; the handwriting, however, is difficult to read, and although the first name is definitely Lillian, the last name is less certain. She was fourteen years of age, born in September 1896 in either Germany or Poland. She was a lodger and a factory worker. She is listed as a Polish Catholic living on King Street in Beamsville in the Niagara area, close to the southern shore of Lake Ontario. Could this be Lillian Alling? The age and place of birth are right and the town of Beamsville did have woollen mills, fruit-packing plants and a factory for making bushel baskets and trugs for the fruit-packing industry—all of them places where a young non-English-speaking girl could have found work.

When asked for her religion by the Customs officer, Lillian said that she was Catholic, so I thought it

was possible she attended a church of that denomination while living in Toronto; St. Stanislaus, the main Polish Catholic Church in Toronto during that time, has no record of anyone named Lillian or a variation thereof for the period between 1914 and 1924.[6] As she also told the Customs officer that she was married, I searched Ontario's marriage records, but turned up nothing. "The Catholic Church in Ontario was the official record keeper for vital statistics, and they took that responsibility very seriously," said Marc Lerman, director of archives for the Archdiocese of Toronto.[7] No record of anyone with the first name Lillian marrying anyone with the last name Alling could be found. I double-checked by using the genealogical database, Ancestry.com, to search for a record of residence or marriage in Ontario, but had no success.

Lillian must have crossed the border into the United States some time between 1921 and 1926, but the government of Canada did not keep records of people leaving the country, including those moving to the United States. In fact, there was a continuous undocumented movement of new immigrants between the United States and Canada as late as 1924.

Lillian told the Customs officer that her last place of residence before returning to Canada was the city of Rochester, which in the early twentieth century was an important centre for the garment industry, especially

for the manufacture of men's clothing. I made a search of the available online databases and contacted various government agencies—both state and federal—for archival information. No records for Lillian were found at the US National Archives and Records Administration.[8] Her name did not come up in State Department records because she was not an American citizen. I also checked the US naturalization records and the United States Social Security Indexes[9] because in 1922 Congress passed the Married Women's Act, also known as the Cable Act, which gave each woman a nationality of her own. Thus, whether Lillian was married or not, she could have applied for citizenship. But there is nothing in their records. No listings for an Alling groom and a Lillian bride were found in the New York City records or in those of the city of Rochester.[10] I sent a request to the State of New York Department of Health, which is responsible for the vital records in that state, to look for any woman with the first name Lillian marrying any man with the last name Alling for the years 1920–1926. No record was found.[11] Searching the US census records for New York State in both 1920 and 1930, I found a number of women named Lillian Alling, but all were born in the United States. Although the Rochester Directories for 1921 through 1926 have a number of Allings, none of these people has the first name Lillian.

(The Allings were a prominent family who had a successful paper company in Rochester.) The records from the Church of the Latter Day Saints have nothing on Lillian. I can only hope that in the future more records will be available, and some traces of Lillian will be found in the State of New York.

Next I asked myself why Lillian Alling decided to go home to Poland and why she set out in 1926. To none of the people she met on her travels did she ever give the reason why she wanted to go home through Siberia. In fact, she never gave a reason why she wanted to go home at all.

Improvements in the economic situation in Poland may have influenced her decision to return. It has been estimated that between one-quarter and one-third of all immigrants from Poland who entered Canada in the early twentieth century returned to Poland either before 1914 or after the war was over in 1918.[12] Those who returned after World War I did so in the hope that their newly independent republic would provide a brighter economic future, but those returning directly after the armistice were disappointed because war with Russia continued until the end of 1920, and political instability remained until 1926 when Marshal Pilsudski assumed the role of dictator.

It is also possible that she decided to go home because she felt she was no better off in North America. Although most Polish immigrants had come to this country and the United States to escape the hopeless economic situation in their own divided country, the jobs that many of the women among them found on this side of the Atlantic were not much better than slavery. In the 1920s immigrant female workers earned less than male workers doing the same job. They were fined for minor infractions, and employers sometimes made deliberate mistakes on paycheques. In addition, women employees were often charged for supplies; in the case of the garment industry the costs of thread and electricity were deducted from their cheques. Foreign workers, especially those from eastern Europe, were frequently excluded, alienated and insulted by their fellow workers and their employers.[13] To escape discrimination on the basis of their ethnic origins, immigrant women often worked in the ghetto sweatshops of their own communities, which did not guarantee good working conditions but gave them the comfort of using their own language and customs. By far the majority of immigrants—85 percent in the case of Polish immigrants—chose to work for employers of their own nationality.[14]

Lillian may also have worked as a domestic servant while in North America. Irene Woodcock, who met Lillian

in the settlement of Kuldo, near Hazelton, BC, in 1927, recalled some sixty years later that Lillian had said,

> [S]he'd been brought over as a domestic by a doctor and his wife in New York City, and they didn't treat her too good. All she did was work, work, work and they never gave her any money, at least, not enough that she could save to get home.[15]

By using the phrase "she'd been brought over," Woodcock implied that Lillian's stint as a domestic had occurred when she first came to North America—that is, before she claimed to have lived in Toronto—and she seems to have also believed that Lillian was only briefly here and had only worked at that one job. Although in some ways domestic workers had a good life compared to those who worked in factories, they often experienced sexual, physical or emotional abuse from their employers. Few of these cases were reported. Many domestic workers were also ill-treated financially; in most cases both the cost of their passage to North America and their living expenses were deducted from wages, and since in many cases their wages equalled their expenses, there was little opportunity to save or to send money home as would have been expected by their families in the old country.

What situation Lillian was leaving one can only guess, but if she was leaving an employer, Christmas Eve would have been a good time to do it. She probably had Christmas Day off from her job, and by leaving on Christmas Eve, she would have ensured no one would miss her until the day after Christmas. In addition, she may have felt that leaving the United States would make it more difficult for her employer to locate her. She may also have been spurred to return to Poland by news from her family there. In an article entitled "The Girl Who Walked Home to Russia" that appeared in *The Bedside Coronet* in 1962, author Allen Roy Evans wrote that Lillian had received a letter stating that her father, mother and brother had been sent to a Siberian prison camp. Her brother, Gregor, had been a minor government clerk, and as a member of the bourgeoisie, he would have been out of favour with the Soviets.[16] Evans produces nothing to corroborate this story, but it makes sense because Lillian always said her destination was Siberia, not Poland. It also has the ring of truth since she did not acknowledge any ties on this side of the Atlantic. Although she told the Customs officer that she was married and that she was a housewife and planned to continue being a housewife upon arriving in Canada, she also listed no relative or friend as her contact person in Canada and answered "none" when asked to

name her nearest relative. This would suggest that either there was no husband, or that she had put her marriage behind her, and that all members of her birth family had been left behind in Poland.

But why would Lillian choose to return to Europe by foot, when boat passage was clearly faster and much less arduous? Perhaps she was trying to return home undetected and she felt Siberia offered her an opportunity to slip into the country or maybe she realized she did not have the financial means to return any other way. In 1926 passage on a ship to northern Europe would have cost approximately two hundred dollars. The average annual wage for a woman in the textile industry in 1926 was eight hundred dollars for a ten-hour day: approximately four hundred dollars below the basic standard of living. Domestic workers like Lillian earned even less. Even if Lillian had worked steadily in the three years that it took for her to walk to Siberia, she could not have saved the money to buy a ticket even in steerage.

Evans said in his article that Lillian walked home rather than taking a boat because a waiter in New York stole her savings.[17] We know this not to be true because she was carrying twenty dollars when she crossed the border into Canada. The twenty dollars probably represented months of savings and to Lillian it was a meagre but dependable resource for her long journey home.

The Carlton Trail passes just south of Wakaw,
Saskatchewan. Lillian's name is at the bottom
of this sign listing the "Carlton Trail Trekkers."
PHOTO CATHERINE SPROULE

Crossing Canada—Spring 1927

*D*espite extensive research in museums, archives and libraries across Canada, I was unable to find any verifiable documents confirming the route, the method of travel or the timetable for Lillian Alling's journey between her December border crossing at Niagara Falls in 1926 and her arrival in Winnipeg the following spring. However, it is possible to piece her route together by examining the usual routes and documented adventures of other foot travellers at that time as well as the legends and stories about Lillian's own travels. Her route would probably have taken her first to Hamilton, then Toronto, directly north to the mining town of Sudbury and then west on what would later become part of Ontario Highway 17 (and still later the Trans-Canada Highway) to Sault Ste. Marie. As no road

Lillian would likely have passed through Sault Ste. Marie, Ontario, on her way across Canada in 1927. The photo shows the old Barnes drugstore in Sault Ste. Marie. SAULT STE. MARIE MUSEUM

over the top of Lake Superior existed at that time, she would have had to follow local roads and the Canadian Pacific Railway tracks to Kenora and thence to Winnipeg. (The road over the top of Lake Superior was not constructed until the late 1950s as a result of the Trans-Canada Highway Act.)

In conversations later in her journey she insisted that she walked the entire distance across Canada, and if she walked approximately eight hours per day through the rough up-and-down terrain of the Canadian Shield,

Lillian stopped briefly in Winnipeg, Manitoba in 1927.
BC ARCHIVES B–07248

it would have taken her at least two months to walk
the 1,300 miles (2,100 kilometres) from Niagara Falls to
Winnipeg where, according to one source, she arrived
around March 1, 1927.[1] Winter, however, was not the
best time to be setting out on a journey through Cana-
dian Shield country. Sudbury's average temperature in
January is -13.7°C and in February -12.7°C, while the
average snowfall in January is 54 cm and in February
44.8 cm. Sault Ste. Marie averages -10.5°C in January
and -19.7°C in February with average snowfall of 81.7
cm in January and 42.8 cm in February. Alternatively,

she may have stayed in Niagara Falls or Toronto from December 1926 until the spring of 1927 before embarking on her travels westward. But if then she walked the entire distance from Niagara Falls to Winnipeg, the date for her arrival there would be much later than March 1, and this would also make it impossible for her to arrive in Hazelton, BC, in September—which she did. It is also possible, however, that she used some of the twenty dollars that she had on her person when she crossed the border to take the train at least part of the way west to Winnipeg. However, even at 1927 train fares of approximately two cents per mile, this may have been too much money for her to spend. On the other hand, she may also have accepted rides as it is known that she did so later in her journey.

An extensive article about Lillian Alling written by Richard W. Cooper and published in the magazine *Western People* in 1985 describes Lillian's journey west from Winnipeg:

> About March 1, 1927, she arrived in Winnipeg. Here she felt the most at home, for many Winnipeg people spoke her language. She stayed until the end of March, working as kitchen help in Child's Restaurant on Portage Avenue, where she was known as a good worker who kept

to herself. She was next seen in Neepawa, Manitoba, where she stopped with a farm family for a few days, helping around the farm in return for food.

The next reasonably accurate report of Lillian Alling came from Kamsack, Saskatchewan. Then there was a definite report of the lone woman hiker in Wakaw, Saskatchewan, where she checked with the RCMP detachment on the shortest route to Alaska. Police records from Wakaw indicate she arrived about the end of April; she had averaged more than 30 kilometres a day on her journey northwest.

On May 2 Alling set out from Wakaw and was not heard of again until she appeared in Grande Prairie, Alberta, on June 15, 1927. A farmer's wife said the Russian woman was then wearing some new clothing. She worked as household help in a Grande Prairie farm until early in July then again set out on what had now become an obsession. Her farm employer gave her a lift to Pouce Coupe where she crossed into British Columbia.[2]

Naismith's Rule

According to the formula devised by the Scottish mountain climber William Naismith in the late 1800s—a formula still used by hikers today—it is possible for the average hiker to cover three miles (4.8 kilometres) of flat terrain in one hour. However, when the hiker leaves flat terrain, he must factor in an additional half hour of walking for every 1,000 feet (305 metres) of total ascent. This is not just the difference between the highest and lowest spots on the route. The total ascent is the sum of the entire uphill distance he walks. That is, if the hiker climbs from zero elevation to 1,000 feet in elevation twice within that three-mile stretch of hiking, his total ascent is 2,000 feet (610 metres) and his time for that stretch of the trek will be increased by one full hour, not one half hour. Thus, Naismith's Rule says that it will take that hiker two hours to walk that three-mile distance at a speed of just 1.5 miles (2.4 kilometres) per hour.

Although the travel time and route for Lillian's journey across the Prairies as given in Cooper's article are perfectly reasonable, I was unable to confirm any of the

details he stated. I made two requests to the RCMP for access to information on her presence in Wakaw that summer and all other points mentioned in Cooper's article but they turned up nothing, and I found no corroborating information in museums, archives or microfilmed newspapers.

It is possible that Lillian did walk from Pouce Coupe to Hazelton, but the route was by no means easy at that time. There were no highways in northern BC. Between Grande Prairie and Pouce Coupe there was a country road that farmers and other country folk used to travel between the two provinces. From there old pack trails existed that had evolved from the original First Nations trails. If Lillian made it through the Peace River area, then she could have used the northern fur trade routes to get to Fort St. James, from which pack trails led directly to Hazelton, her next known stop. This route also had the advantage of ferries across the larger lakes.

> *When questioned Lillian insisted that she walked the entire distance across Canada.*

R.G. Harvey, former deputy minister of Highways for British Columbia and an expert on early travel

This raft ferry at Germansen Landing carried passengers across the lake. BC ARCHIVES I–33980

routes in the province, agrees that "if she came through Pine Pass [which today is the route of the John Hart Highway (#97)] in 1927, she must have used the Indian trail. It was one of the many trails used by the Indians of the Interior to come to the coast to trade buffalo hides for salmon and oolichan [oil]. From there she could either have gone south to Fraser Lake and followed the [Canadian National] railway to Hazelton … or she could have gone north to Germansen Landing and then west by a trail to Hazelton … This trail was built in the 1870s to give access to the Omineca gold field and

was a continuance of the old Hudson's Bay Brigade trail [and was] probably quite usable in 1927."[3] Although Mr. Harvey says that "he would like to think she took the miners' trail," the route via Fraser Lake and the railway line seems the most likely one as it is shorter, and she is known to have stopped in the village of Evelyn, just west of Smithers on the Canadian National line.

Alternatively, Cooper may have been misinformed and Lillian may not have gone so far north as Grande Prairie, instead walking along the rail line through Jasper and the Yellowhead Pass. It was a well-maintained line and very popular with tourists by that time. The *Omineca Herald* of August 5, 1927, reported that "the special summer excursion run by the Canadian National Railways from Vancouver return to Vancouver via Jasper Park and Prince Rupert, passed through here last Sunday morning. It was well patronized."[4] And finally, it is possible that she took the route through Banff and the Kicking Horse Pass, although this would have added many more miles to her journey.

The summer of 1927 was the hottest on record in the Hazelton area,[5] but fortunately by September when Lillian would have been tramping through the Bulkley Valley the weather had cooled, temperatures topping out at 25°C. It is here, almost 1,500 miles (2,400 kilometres) from Winnipeg—the last place east of the Bulk-

ley Valley I can verify that she visited—that I was able to pick up Lillian Alling's trail again. People were becoming curious about the lone woman hiker and extended hospitality to her. Northwest of Smithers, in the farming community of Evelyn, Mollie Rolston, née Owens, was just six years old when Lillian Alling stopped at her family's home. In an interview with David Gordon Duke, published in the *Vancouver Sun* on October 13, 2010, she recalled that

> A lot of people travelled the railway ...
> We lived right on the railway, and people
> dropped in because they wanted a meal
> or place to stay ... Of course, in my day
> six-year-olds didn't listen to adult conver-
> sation.

But Mrs. Rolston did remember Lillian's appearance on that occasion.

> She wasn't blond. She had a head cloth
> that she used to protect herself from the
> insects. She was given clothes by people
> along the way. She had a very plain face,
> and she was lucky if she was able to wash
> herself much. When she came to us, she
> had long hair and wore ordinary tennis
> shoes. No doubt she wore out boots as

she went, but she was in tennis shoes then. She carried a cardboard box that she had everything in, about the size and shape of a beer case; she had a rope or something around it. And she wore a dress.[6]

While I was researching her journey, I often wondered if she was ever afraid, and I realized that she probably was. But by the time she got to Hazelton, she had been about nine months on the road, and as her physical abilities became stronger and she honed her bushcraft, fear had most likely turned to confidence. She seemed barely bothered by trials that would challenge even the most seasoned of hikers. She had walked up mountains, through rough terrain where there was no path, through floods, freezing weather and searing hot sun. Canada is a cold and snowy place in the winter, but in the summer the daily temperatures can reach 40°C with no wind. Yet on she walked. She had become a true survivalist in every sense of the word.

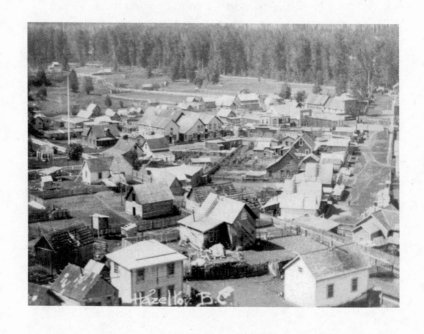

Hazelton, BC, in the 1910s. BC ARCHIVES B–00493

Chapter Three

Fall and Winter 1927

The Gitxsan people have called the area near the confluence of the Bulkley and Skeena rivers home for centuries, but after European settlement began there in the 1860s, the newcomers named this place Hazelton after the many hazel bushes that are found in the area. For many years it served as the terminus for the sternwheelers that brought goods and passengers up the Skeena River, but that traffic ceased in 1912 after the Grand Trunk Pacific Railway was completed to Prince Rupert.

Lillian Alling seems to have arrived in Hazelton in early September 1927, but she was not the only woman hiker to have turned up there that summer. The *Omineca Herald,* published in the nearby village of New Hazelton, reported on August 27, 1927, that:

> Nell Walker blew into town last Tuesday [August 23] and announced herself the world's champion walker and she appeared at the Hazelton theatre that evening and again proclaimed herself champion and showed some pictures and gave a talk to prove it. She has been on the wing, or foot, for two and a half years and has gained considerable weight and experience in that time. She aims to visit all the capitals of the world within five years, hence her visit to these parts. She figured on going back to Smithers and thence to Prince George. She had better head south pretty soon or the going will not be so good when the wind begins to blow and the snow begins to fall.[1]

Unlike Nell Walker, Lillian Alling did not announce her arrival to the people of Hazelton nor was her presence heralded by the local newspapers. Instead, she quietly turned her steps northward and began to follow the Telegraph Trail, the rough foot trail along the telegraph line that went to Atlin and from there to Dawson City. Her journey took place in the twilight years of the Trail. In 1925 six of the eleven stations situated between Hazelton and Telegraph Creek had been closed,

leaving only stations two, four, six, eight and Echo Lake manned. The closures meant that the distance between the operating stations was now approximately 50 miles (80 kilometres)—according to Bill Miller in his book, *Wires in the Wilderness,* the average distance would have been 40 miles[2]—and this meant twice the work for the linemen who had to fix breaks in the line. From the station a lineman could tell the direction of the break but not its exact location. So the linemen from the two stations on either side of the break would walk toward each other.

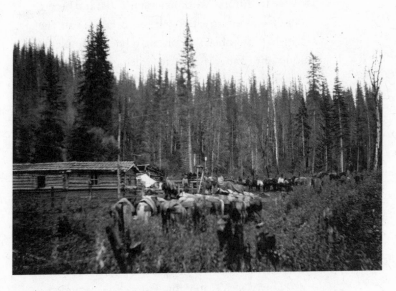

The fourth cabin on the Yukon Telegraph Line, c. 1911. BC ARCHIVES A–05356

The Yukon Telegraph

In 1858 the Atlantic Telegraph Company, owned by Cyrus West Field, laid the first undersea telegraph cable across the Atlantic Ocean. When it broke three weeks later and further attempts were unsuccessful, entrepreneur Perry Collins approached the Western Union Telegraph Company with the idea of an overland line from San Francisco north to Alaska, across to Siberia and thence to Europe. Work began in 1864, and before winter caused work to cease in late 1865 the British Columbia section had been completed along the Fraser River to Yale and northward beside the newly completed Cariboo Road as far as Quesnel. When work resumed the following spring, the line was pushed northwest for another 400 miles (645 kilometres) to the Kispiox and Bulkley rivers. By July 27, 1866, they had reached the junction of the Bulkley and Skeena rivers, where the new settlement of Hazelton was created, and word came that Cyrus Field had successfully laid an undersea cable across the Atlantic. As the Collins Overland Telegraph Line was now considered obsolete, work was halted on February 27, 1867.

Thirty years later this failed line provided a surveyed and tested route for the construction of

the Yukon Telegraph Line, which was initiated by the federal government during the Klondike Gold Rush years in order to provide overland communication with the north. The new line began in Ashcroft where the trans-Canada telegraph line lay alongside the CPR main line. It then followed the old Collins line through to Hazelton, and from there to Atlin and on to Dawson City in the Yukon. It was completed in 1901.

In order to maintain the 300-mile-long (500-kilometre) line through the wilderness between Hazelton and Telegraph Creek, fourteen cabins were built about 25 miles (40 kilometres) apart and each cabin was manned by a lineman and an operator; the lineman patrolled 12.5 miles (20 kilometres) north and 12.5 miles south while his partner relayed messages between cabins and with the outside world. Smaller refuge cabins were built between the main cabins. Food and other supplies were brought in once a year by pack train from Hazelton to the first nine cabins and to the remainder from Telegraph Creek.

By 1936 shortwave radio had proven more effective than the telegraph for distance communication, and after heavy snows brought down much of the line that winter, the entire line was shut down. The following summer floods washed out more sections of the line. It was never replaced.

If it could be fixed quickly, they would soon be back in their respective stations; if not, they would stay overnight in one of the refuge cabins constructed at 10-mile (6-kilometre) intervals on the line. Though smaller than the main telegraph stations, they were equipped with stoves, beds and emergency provisions.

The first place Lillian stopped on the Telegraph Trail was the tiny settlement of Kuldo, north of Hazelton, and there she met Irene Woodcock. In an interview in 1990, Woodcock remembered that meeting:

> She was a rather short, squat person. I was in my twenties, and I figured she was older than me. I couldn't figure out how she'd found our house, but there she was. I asked her in and talked her into having dinner with us, instead of eating the bread she carried. That's all she carried, a loaf of bread and a big stick. The bread to eat, and the stick so that no one could stop her from going where she wanted to go. She talked English pretty good—it was broken, but I had no trouble understanding her.

Woodcock then recalled Lillian telling her that she had served as a domestic for a doctor and his wife before deciding to walk home via Alaska and Siberia. "Years

later I heard somewhere that maybe she made it. I always hoped she did."[3]

On September 19, 1927, when Lillian arrived at Cabin Two, 50 miles (80 kilometres) up the Telegraph Trail, she was tired and bedraggled. Bill Blackstock, the Yukon Telegraph operator at Cabin Two, didn't get many visitors, especially this late in the year, but Telegraph Trail etiquette required him to provide hospitality to all visitors and Lillian was no exception. He fed her and then asked where she was going.

"Siberia," Lillian said.

This was a surprising statement. But Blackstock knew she wouldn't make it more than a few hundred miles up the trail, at most, at that time of year. While it was only late September, the high altitude of the route ahead made for dangerous travelling conditions, and winter would be closing in very quickly. Fearing for her safety he telegraphed the Provincial Police detachment at Hazelton and told them about her. Constable George A. Wyman arrived at Cabin Two at 12:30 a.m. on September 20. He arrested Lillian and brought her back to Hazelton.

George Wyman had only joined the force in January of that year, and began his duties as a junior constable at the Hazelton Detachment on January 12. Thirty-six

years later he recalled his arrest of Lillian Alling in an interview with journalist Donald Stainsby.[4]

> I was so surprised to see that woman there. She was so scantily clad and had no fire-arms or anything to see her through that country. She was about five foot five and thin as a wisp. When I first saw her, she was wearing running shoes. She had a knapsack with a half-dozen sandwiches in it, some

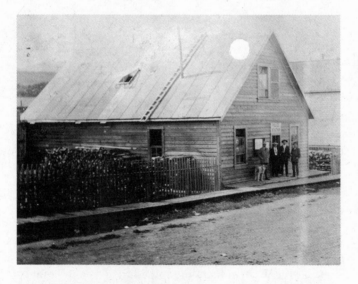

Lillian was arrested and brought back to the Hazelton Police Station on September 20, 1927. BC ARCHIVES F–06342

tea and some other odds and ends, a comb and personal effects, but no make-up. I had a time getting her name; she wasn't going to say anything to anybody. But I finally got it, and when she said she was going to Siberia, I couldn't say anything. I thought she was out of her mind.[5]

Lillian came back to Hazelton with Wyman without protest. Once there, Wyman called his superior, Sergeant William J. Service, at Smithers, which is about 50 miles (80 kilometres) southeast of Hazelton. Although Lillian's English was good, Wyman found it difficult to get information out of her.

"Feed her and see if she'll talk," said Service.[6] Then he suggested they charge her with vagrancy in order to save her life from the upcoming winter.[7]

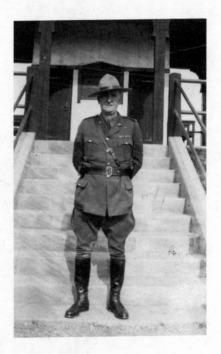

Sergeant William J. Service.
BC ARCHIVES I-83232

Cabin Two where Lillian was arrested by Constable George Wyman on September 20, 1927. BC ARCHIVES D-09112

Wyman recalled in his interview with Stainsby that Lillian had finally told him that she had come to New York City from Russia, but she would not tell him why she had come. He also remembered that she had told him she had been a maid in New York and after she realized it was impossible to save for a steamer ticket fare back to Russia, she looked at the maps of North America in the public library and decided to walk.[8] "She was the most determined person I'd ever met," Wyman said.[9]

The only record of Lillian's arrest I was able to find was in a 1941 issue of *True Magazine*, a journal that published outdoor adventure stories for men. As part of an illustration on one page of the story, there is a photographic copy of Lillian's arrest record. The archivist at the Brown University Library, where I located this issue of *True*, said the magazine was too fragile to photograph, but he was able to photocopy it for me. The arrest record is for *Rex v. Lillian Alling* of Winnipeg, Manitoba. This was the first official, written record I found in which Lillian had stated her last residence as Winnipeg.

Wyman and Service decided to lay a vagrancy charge against Lillian, so the next day, Wednesday, September 21, she was brought into Provincial Police Court in Hazelton in front of William Grant, a local Justice of the Peace.[10] The charge reads that Lillian Alling, "not having any visible means of subsistence, was found unlawfully wan-

Policing British Columbia

In the 1920s, policing was in transition in British Columbia. In 1919 the North West Mounted Police, forerunner of the Royal Canadian Mounted Police, had replaced the Dominion Police in the four western provinces as the enforcers of federal laws. They were responsible for such jurisdictions as Indian Affairs; Immigration; Customs and Excise; and War Measures.

In 1924 the British Columbia Provincial Police, formed in 1871, took over the responsibility for enforcing many of the federal statutes as well as provincial laws. With this change in status, the Provincial Police, who had worn civilian clothes to this date, were finally issued uniforms. This change was not without controversy, however, because some members were concerned that the uniforms made the police less approachable by the public. In 1950 the British Columbia Provincial Police were merged with the Royal Canadian Mounted Police.

dering around at 30 Mile, Yukon Telegraph Line in the County of Prince Rupert." The report form goes on to say that she was arrested and placed in the Hazelton lockup by Constable G. Wyman. However, there was one problem with charging her with vagrancy—she had twenty dollars on her person and was therefore not a vagrant. Fortunately, it was then discovered that she had an iron bar concealed in her clothing, and Justice of the Peace Grant was able to charge her with carrying a concealed weapon.

Wyman recalled:

> [S]he stood silent through the hearing. Grant explained the charge to her and told her, if she wanted to say anything on her behalf, she only had to swear on the Bible to tell the truth. She stood mute. He explained it again, a third, a fourth time. Lillian finally did speak, four loud clear words, astonishing in their obscenity.[11]
>
> Grant, with great forbearance, found her guilty only of the [carrying a concealed weapon] charge and not the contempt of court which she had committed. He fined her the abnormally heavy amount, for that time and place, of $25 and $1.75 for costs, with the

alternative of two months in Oakalla Prison Farm in Vancouver.[12]

Wyman's 1963 account is backed up by his original report with only a small discrepancy in the court costs; his 1927 report stated that Lillian pled not guilty but was found guilty and fined twenty-five dollars plus seventy-five cents in court costs or two months in Oakalla.

Apparently Lillian said nothing more in court.[13]

Bill Kilpatrick, grandson of William Grant, says that the tale of Lillian and her encounter with his grandfather has been passed down through the generations. "My grandad put her in jail so she wouldn't freeze to death," said Bill.[14]

After Lillian had been put in the Hazelton jail, another police officer, Royal Canadian

Besides being a Justice of the Peace, William Grant was a notary public and carried on a real estate and insurance business in Hazelton. He was also secretary of the school board for twenty-five years. The child in this picture is Norman Grant Kilpatrick. PHOTO COURTESY OF THE KILPATRICK FAMILY.

Mounted Policeman T.E.E. (Ern) Greenfield, was called in to assist Constable Wyman. In a letter to the *Province* newspaper, published on May 2, 1973, Greenfield recalled that:

> Constable Wyman had to go out of town on an urgent matter and he asked me to do the gaol guard duty until his return. I happened to be in Hazelton on patrol duties and it was not infrequent that members of the R.C. Mounted Police were asked and readily gave the necessary assistance to the provincial police.

He then described Lillian's appearance the first time he saw her.

> Lillian's effects consisted of a man's heavy cloth overcoat that hung to ankle length in which she slept. She carried an iron bar about sixteen inches long for defence purposes. She had a landing card showing her arrival at New York early in 1927 and showing her to be Polish. Her name on the card was spelled Ailing. She wore a pair of men's eight-inch top boots.

Greenfield's recollections do not correlate with other known facts. The landing card issued in New York could

not have been dated early in 1927 because her entry into Canada at Niagara Falls was dated December 24, 1926, and Greenfield is the first person to suggest that her name was something other than Alling. His letter to the newspaper was, of course, written some forty-four years after Lillian's arrest in Hazelton, which may account for the discrepancies. Three years after his letter to the *Province*,

This sketch of T.E.E. Greenfield was made by Paul Cote at Kitwanga in 1928. COURTESY OF THE GREENFIELD FAMILY

Greenfield wrote a book, *Drugs (Mostly)*, about his professional experiences and Lillian rated a mention in it as well. This time he said that "she wore a stout dress, heavy walking boots, a bulky winter overcoat and carried a small bundle wrapped in a kerchief."[15] If this description is true, she had acquired this clothing since Constable Wyman first saw her on September 20, when she was inadequately clothed and wore running shoes. Greenfield's nephew, Harley Greenfield, remembers his uncle's stories about Lillian. "Uncle Ern had pretty mixed feelings about having to apprehend this lady, but she had no idea

of the area or the territory," said Harley. "This was a gritty woman. She was an amazing lady, a great hiker."[16]

Wyman's arrest report, dated September 24, 1927,[17] shows that Lillian was moved to Smithers, BC, and from there taken to Oakalla Prison in Burnaby, a suburb of Vancouver. According to journalist Donald Stainsby, Mrs. Bud (Isabelle) Dawson, who with her husband operated the Omineca Hotel in Hazelton, was sworn in as a special constable to escort Lillian there.[18] Greenfield, on the other hand, remembers Lillian being escorted to Oakalla by prison matron Constance Cox. According to the Hazelton newspaper, the *Omineca Herald*, when prisoners from Hazelton needed to be escorted to prison in the Lower Mainland, they were taken by train to Prince Rupert and travelled south from there by boat. In his book, *Drugs (Mostly)*, Greenfield explained that he and William Service of the Provincial Police often took prisoners on the Canadian Pacific's SS *Prince Rupert*,[19] so it is possible that Lillian was taken to Vancouver on the CP's *Princess Louise,* which left Prince Rupert on September 30, 1927, and arrived in Vancouver on October 2.[20] However, no passenger records exist for domestic travel,[21] and I found no mention of Lillian Alling's travels through Prince Rupert in

> *"This was a gritty woman ... an amazing lady, a great hiker."*

the *Prince Rupert Daily News* or the *Evening Empire* newspaper for August, September or October 1927.[22]

I have also been unable to locate any records of Lillian's time in Oakalla Prison. My requests to the British Columbia Archives revealed that they had "received several requests over the years for records concerning Lillian Alling. Our archival holdings were thoroughly searched but no such records were ever found."[23]

In 1927, when Lillian served her jail time in Oakalla, there was still no separate prison for women. She would have been placed in the general prison population,

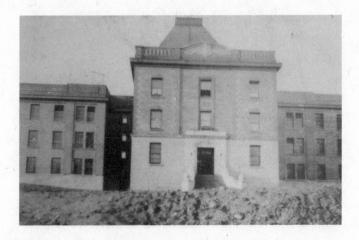

Lillian must have had a lonely and difficult time in BC's harsh Oakalla Prison. HERITAGE BURNABY 370-720

though the women and men spent the night in segregated cells.[24] It was a brutal life for anyone to endure, but Lillian, having spent so much time outdoors, must have found it a sad contrast to the freedom she had previously enjoyed. Although Greenfield stated in his 1973 letter to the *Province* he was convinced that "after five days had elapsed Lillian was released immediately,"[25] George Wyman said that:

> At Oakalla Lillian Alling was considered a cooperative prisoner by the matrons and was liked by her fellow prisoners. She won her release on November 11, 1927. This was just ten days before her sentence was to expire.[26]

After serving her sentence, Lillian appears to have spent the next six months or so in the Vancouver area, working, saving money, and biding her time until the travel conditions were favourable. By May 1928 she was on her way north again.

Oakalla Prison in the 1920s

Oakalla Prison, which had opened in 1912, was run by the Provincial Gaol Services, a branch of the British Columbia Police Administration. BC's gaols had adopted the American "Auburn" Prison philosophy of hard work, strong discipline and silence. This system, which was developed at the Auburn prison in New York State, was predicated on the idea that criminal habits were learned and reinforced by contact with other criminals. Therefore, prisoners were subject to brutal discipline, forced to work in silence during the day and segregated in separate cells at night.[27]

By 1927, Oakalla Prison had developed a particular reputation for harshness as Earl Andersen, author of *Hard Place to Do Time*, descibes:

> By the end of the Roaring Twenties, lavishness and free-spirited prosperity prevailed in cities throughout North America, and Vancouver was certainly no exception. However, within the walls of Oakalla, only a few miles away in the tranquil suburb of Burnaby, conditions were still austere. The wardens maintained a tight rein of control over their prisoners.[28]

*Stewart, BC. Six months after being released from prison Lillian
headed north again, most likely travelling to Stewart by ship.*
BC ARCHIVES D-00196

Chapter Four

Hyder, Alaska, to Smithers, BC

*I*n the 1920s, the most efficient way to travel from town to town along the coast of British Columbia was by ship. Three or four boats called in every week at Stewart, which sits right at the head of the Portland Canal, the 70-mile-long (115-kilometre) fjord that forms part of the US/Canada boundary in the north. The line runs right up the centre of the canal; everything on the east side is in Canada and that on the west side is in the US. A tourism booklet from 1928 says that those travelling the 700 miles (1,100 kilometres) between Vancouver and Stewart will:

> [S]ail through a system of enclosed water-ways having no parallel elsewhere in the world, with all the comforts of a trans-Atlantic liner. Canadian National and

Union Steamship Companies' steamers
are noted for their comfort and safety
and make the round trip in six days.[1]

It was probably on one of these ships that Lillian
arrived in Stewart at the beginning of June 1928 on her
second attempt to get to Siberia. Travelling up the canal,
she would have seen its spectacular beauty, as described
by L.A.N. Potterton:

The mountains were steep-sided with ice-
eroded valleys, some of which contained
living glaciers. They were covered with
lush green timber reaching high towards
the heavy blanket of snow which covered
the high peaks that gave birth to scores of
milk-white streams and waterfalls.[2]

When Lillian arrived by ship at the beginning of
June 1928, the towns of Stewart and Hyder, BC, and
Hyder, Alaska, plus the surrounding mining communi-
ties, had a total population of about a thousand peo-
ple. After disembarking at Stewart, she set off along the
boardwalk to walk through Hyder, BC, and into Hyder,
Alaska. The date was June 6, and at the United States
Customs and Immigration Office at the entrance to
the American town, she met Colonel Edwin R. Stivers.
He had opened an office there on March 31, 1921, and

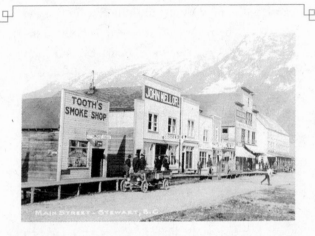

Stewart, BC, c. 1920s. UNIVERSITY OF WASHINGTON LIBRARIES AWC2933

The decision that the international boundary between British Columbia and Alaska should be located at the centre of Portland Canal was finalized in October 1903, although the treaty was not officially signed until May 14, 1910. However, even before that decision was made, the towns of Stewart and Hyder, Alaska, had been founded at the head of the Canal in response to the discovery of enormous mineral wealth in that area. The first lode mineral claims in the area were staked at Bitter Creek by D.J. Rainey in 1899. He also staked out forty acres on the mud flats of the Bear and Salmon rivers, which empty into the head of the

canal, but as he was not sure if he was in Canada or the US, he recorded his claims in both countries. In 1903 prospectors Robert M. and John W. Stewart arrived, secured a portion of Rainey's holding and staked the townsite of Stewart at the farthest end of the canal between the mouth of the Bear River and the international boundary. (This town has the distinction of receiving the greatest average annual snowfall of any town in Canada—18.75 feet or 572 centimetres.) The new town gave miners access to mines on the Canadian side of the line and experienced its first boom in 1910. However, its real economic success came with the opening of the Premier Mine, 15 miles (24 kilometres) north of the town. This mine operated from 1919 to 1953, producing gold and silver ore and paying out thirty million dollars in gross earnings.

The American town of Hyder, named after Canadian mining engineer Frederick Hyder, was established 2 miles (3 kilometres) south of Stewart. It sits on a point of land between the Portland Canal and the mouth of the Salmon River, although part of the town was constructed on pilings pounded into the mud flats. (This portion of the town was destroyed by fire in 1948.) In its

early days, Hyder was primarily an access point to the Riverside Mine, north of the town, where gold, silver, copper, lead and zinc were extracted between 1924 and 1950, but the town's boom years occurred between 1920 and 1930. Although a few ships called at Hyder when they had freight for the mine and some of the smaller passenger vessels from Ketchikan stopped there on a more or less regular basis, most of the passenger vessels that came up the canal were Canadian and their port of call was Stewart.[3]

A third town, Hyder, BC, was established between Hyder, Alaska, and Stewart, initially as a place to accommodate a dock and a 4,000-ton

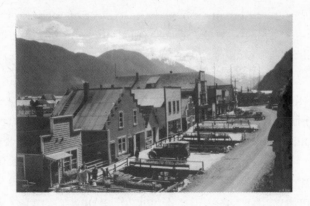

Hyder, BC, was right next door to Hyder, Alaska.
PHOTO COURTESY HYDER ARCHIVES

bunker to store concentrate from the Premier Mine. The 12-mile-long (19-kilometre) aerial tramline that connected it to the mine was the second longest on the continent. This tiny town, which also provided accommodation and entertainment for the mine workers, was built entirely on pilings driven into the mud flats, and its dozen or so buildings faced landward, their backs to the sea. They included a few hotels, a restaurant, two brothels and the offices of the Canadian Customs Service. Today nothing but a few piling stubs remain to show that Hyder, BC, ever existed.

although his main job was the collection of customs duties, over the years Stivers had also taken on responsibility for immigration inspection.

Stivers did not allow Lillian to enter Alaska. According to the official record from the United States Department of Labor, which was in charge of immigration, Lillian Alling, a citizen of Poland, aged thirty-two, female, who had arrived in Hyder "by highway" was "debarred" from the United States because she had no visa. (The term "highway" refers to the 2-mile (3-kilometre) stretch of boardwalk between Stewart and Hyder.)

There was actually no formal entrance policy into the United States at Hyder during the years between 1920 and 1930, so it is possible that she was rejected because she was neither American nor Canadian. According to her own statement at the Canadian Customs office in Niagara Falls, though she had lived in Canada from 1915 until 1921 and had apparently worked in New York State between 1921 and 1926, she had not applied for citizenship status in either country. And if she had held a visa at any time during that period, it was obviously no longer valid.

Changes had occurred in both US and Canadian immigration and travel rules subsequent to Lillian's first entry into the United States from Canada. Although there had been a continuous undocumented movement of people back and forth between Canada and the States during the early 1920s, both countries had tightened regulations for people from Europe. In 1921 the US Quota Act had limited the number of immigrants from Europe to about 350,000 per year, and in 1924 the National Origins Act reduced that European quota to about 165,000. In addition, the United States had introduced Prohibition in 1920, and as a result border controls had gradually become tighter: the production and sale of liquor remained legal in Canada, and the US was struggling to prevent smuggling activity at the border.

COURTESY HYDER MUSEUM, JIM COMER COLLECTION.

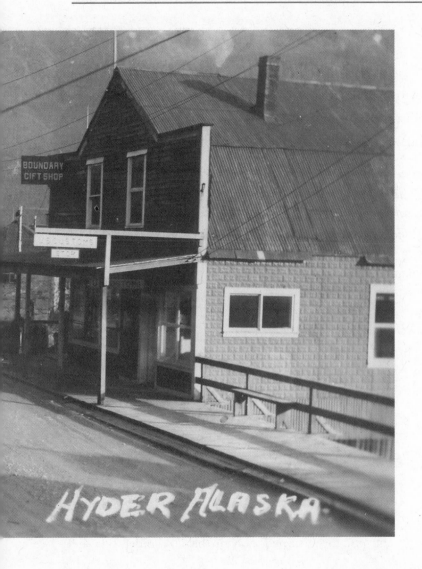

However, it is quite possible that Stivers turned Lillian back at Hyder simply because she had announced that her ultimate destination was Siberia. He would know that she could not possibly reach it by travelling north by land. Hyder is situated on the Alaska Panhandle, that strip of Alaska that divides northern British Columbia from the Pacific Coast. It is a wilderness of mountains and glaciers, thousands of inlets and rivers and streams, gullies and cliffs. Even today, there are no roads and no trails. The only way to get from town to town along this coast is by boat. Walking it would be a physical impossibility. Stivers knew that once Lillian entered Hyder, she had either to stay there, go 14 miles (22.5 kilometres) north to the Riverside Mine or turn around and go back to British Columbia.

The whole town seemed to be involved in gambling and drinking — everyone was making money and spending it just as fast as they made it.

Having dealt with the British Columbia Provincial Police and the Royal Canadian Mounted Police, enduring months in prison and losing an entire year on her journey, it is little wonder Lillian wanted to leave British Columbia and Canada. Thus, she must have been very unhappy to be turned away at the US border. But she

had learned an important lesson in Hyder. By attempting to cross the international border there, she found out she would never get into the United States through an established boundary crossing. Any future attempt at entry from Canada would need to be clandestine.

After being refused entry into Alaska, Lillian needed to make both short-term and long-term decisions. Short-term included where to spend the night, and her obvious choice was Stewart, which was a rather rowdy town at that time. A man who had served there as the local policeman in those days said:

> [T]here were three licensed hotels situated on the main street, and as soon as they opened up for business, they filled up as fast as a church rummage sale, and with the same amount of enthusiasm. The only thing different was the language that was being used.[4]

The government liquor store did the most business in the town. In 1928 it "sold more liquor than any other individual liquor store in the province of British Columbia." L.A.N. Potterton wrote:

> The whore-houses perhaps came next in the line of big business, followed closely by the gambling tables. The local bank

manager once told me that his best cus-
tomers at the savings account level were
the girls from the red-light district ...
The whole town seemed to be involved
in gambling and drinking—everyone was
making money and spending it just as fast
as they made it.[5]

Lillian's long-term options were few. She could wait
for a ship in Stewart that would take her north to Skag-
way, Alaska, and thence over the Whitehorse and Yukon
Railway to Whitehorse, but having been turned down
at Hyder because she had no visa, she would expect to
be turned down in Skagway as well. It is also quite pos-
sible that she did not know of the railway's existence.
Alternatively she could take a ship back down the coast
to Prince Rupert, follow the rail line to Hazelton and
begin a fresh attack on the Telegraph Trail. However,
she may have been unable to afford the fare. Her third
option was to make her way to Hazelton by land.

It is not possible to walk from Stewart directly to
the main line of the Telegraph Trail as the terrain is too
steep and dangerous. Two years before Lillian arrived in
Stewart, surveyors had attempted to lay out a route from
Hyder through the Bell-Irving River valley. The report
of their endeavours is noteworthy:

We discovered a freshly blazed trail, and having followed it, we met a party of Indians camped on Bell-Irving River. These Indians, Gunanoot and party, have trapped in this country regularly for a number of years and know it thoroughly ... they told me they did not think it feasible to build a trail up the west bank of the Bell-Irving because as one approaches the Telegraph Line, the country is subject to very bad snow slides ... my intention was to go up the west bank of the Bell-Irving to the Salmon [Teigen] Creek, cross that stream, stay a night at the shelter cabin on the Telegraph Line at this point and then return along the east bank of the Bell-Irving. But when we arrived at the junction of the Salmon [Teigen] and Bell-Irving about a mile from the Telegraph Line, the rain was falling in torrents and the river was extremely high, consequently ... we had to return as we had come, by the west bank. However, I found that the information given me by the Indians was amply verified. For 5 miles below the junction of the Salmon [Teigen] and Bell-Irving

> the snow slides run clear from the top of
> the mountains into the river and at times
> block it up; consequently it would be
> impossible to maintain a trail here.[6]

Although overland passage to the Telegraph Trail was unavailable, it is likely that Lillian learned that the Cranberry Trail—a trading route used by the Gitxsan First Nations people—was the best route back to Hazelton and the Telegraph Trail. The Cranberry Trail network begins with a 12-mile (19-kilometre) hike up into the canyon of the Bear River and from there through the Bear Pass to Meziadin Lake. The next part of the trail follows the Nass River and then the Cranberry River to the head of Steven's Lake. The final stretch lies alongside the Kispiox River then through the Kispiox valley to Hazelton.

By the summer of 1928, Lillian had been travelling for a year and a half and had walked thousands of miles. But a good portion of that time had been spent in jail or within the confines of the city of Vancouver. Presumeably she was well rested, but probably also out of shape since her last attempt to walk the Telegraph Trail. Now her strength and endurance in the wild would be freshly tested. Most of the journey ahead of her would have been considered a moderate to difficult hike.[7] Through the mountainous sections the terrain was rugged, to be

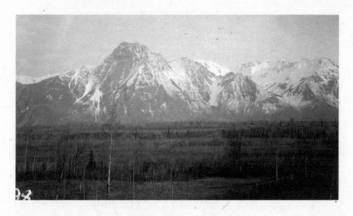

As Lillian hiked through Hazelton and on through the Bulkley Valley, Roche de Boule Mountain served as a striking backdrop. BC ARCHIVES NA–03623

sure, but in the river valleys the trails flattened out, and in the month of June they would have been dry as well. If she walked an average of 30 miles (48 kilometres) a day, it would take her about two weeks to make the journey from Hyder to Hazelton.

However, Lillian did not stop when she reached Hazelton. She walked a further 38 miles (61 kilometres) southeast through the Bulkley Valley to the town of Smithers, arriving there on June 19. It would have been a much shorter trek for her to walk from Hyder to Hazelton, then head directly north, but she had apparently been told by Oakalla Prison authorities to check in with the Provincial Police in Smithers before heading

BC Police Officer Andrew Fairbairn

Born in Scotland in 1888, Andrew Fairbairn arrived in Canada in 1908. After serving with the Investigation Department of the Canadian Pacific Railway, he joined the BC Provincial Police. His early postings included Telkwa, Smithers and Burns Lake; in September 1929 he was promoted to corporal in charge of the Hazelton District and transferred to Smithers. The next year he was promoted to sergeant. In 1934 Fairbairn was transferred to Cranbrook and in 1938 to Grand Forks. In 1941 he was placed in charge of the Courtenay District and two years later, promoted to staff sergeant. In February 1943 he transferred to Kamloops. Then on July 1, 1946, when the BC Provincial Police were amalgamated with the Royal Canadian Mounted Police, he transferred to Williams Lake.[9] He retired to Ladysmith in 1952 and died there at the age of eighty-five in August 1973.[10]

north on the trail again.[8] So she had walked the extra day into Smithers. Perhaps her unsuccessful encounter at Hyder, Alaska, had made her realize that, since the inland Canadian route was the only way north, she would have to comply with police requirements along the way.

Constable Andy Fairbairn of the British Columbia Provincial Police had been expecting Lillian, and he confirmed his encounter with her in an interview with *Vancouver Sun* reporter Donald Stainsby in 1963.[11] Fairbairn had quizzed Lillian about her trip.

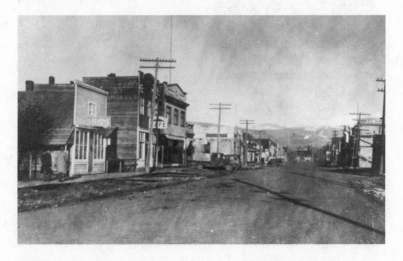

Smithers, where Lillian was kept in custody in 1927, and where she returned to report to the Provincial Police in June 1928, before she headed up the Telegraph Trail. BULKLEY VALLEY MUSEUM

Constable Andy Fairbairn questioned Lillian about her trip.

THE VANCOUVER SUN

"Did you bum rides?" he asked her.

"I walked all the way. I tell you the truth," she said. "I do not tell lies." And this was partially true: although she had taken a ship to Hyder, she had walked from Hyder to Smithers.

Fairbairn remembered that "her face was smooth and clear, her hair, under the inevitable kerchief, was black and shiny." He told Stainsby that she must have averaged between 30 and 40 miles (48 and 64 kilometres) a day on her journey. She asked Fairbairn to let her continue on towards Siberia, and the officer realized that with her proven travelling speed—she had left Stewart on June 7 and it was now just June 19—she might barely make it to the Yukon before the weather got bad, but he was still hesitant about giving her permission to continue because she was so ill-equipped.

"What will you eat? You have nothing." Her packsack seemed woefully small.

"I eat anything," she replied. "Leaves, berries, grass. Please let me go."[12]

Another part of Fairbairn's reluctance stemmed from the fact that an American hiker had attempted to walk the Telegraph Trail but had not made it very far. The *Omineca Herald* of June 20, 1928, reported:

> Owen C. Eastman of Salem, Massachu-
> setts, who blew into Hazelton some time
> ago and posed as a hiker of some ability,
> en route for Paris, returned to Hazelton on
> Tuesday [June 19] a wiser boy. He got as far
> as the fourth cabin on the telegraph line
> when he decided to retreat.[13]

Constable Fairbairn finally agreed to let Lillian go further north on the condition that she report in at every cabin on the telegraph line until she reached Telegraph Creek.

"I will," she said earnestly. "I give my word."[14]

So Lillian headed west again toward Hazelton, where she would turn north up the Telegraph Trail.

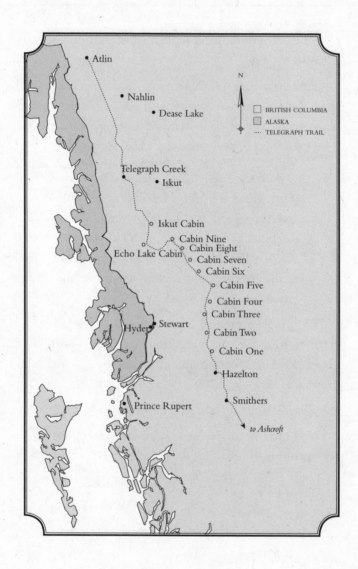

Chapter Five

The Telegraph Trail

fter meeting with Fairbairn in Smithers, Lillian immediately began backtracking to Hazelton. Her arrival there was noticed and reported in the June 20 edition of the *Omineca Herald*:

> Lillian Alling, an old friend of the police force, blew into Hazelton this week en route to Echo Lake. She is on foot and makes on average of twenty miles a day. Last year she was in Hazelton and after a reasonable stay she was charged with vagrancy and drew a six month term in Okala [*sic*] from the magistrate. Lillie is a small woman, wiry and quite capable of taking care of herself.[1]

The route ahead of her was described by Winfield Woolf, who hiked up the Telegraph Trail a year after Lillian:

> The existing gravel road continued thirty-five miles north of Hazelton, then ended in the woods ten miles beyond the last ranch. I soon found myself following a very faint trail over sharp ridges with only the Dominion Telegraph Line overhead to guide me. Nothing in all the forests and mountains surrounding me had been touched by the hand of man except the trail itself and the telegraph line. I knew that six or seven hundred miles of wilderness lay between me and the town of Atlin. Seven-thousand-foot snowy, glacier-laden peaks rose above me.[2]

Constable Fairbairn sent a message to Ruxton Cox, the head telegrapher at Hazelton, who then tapped out a message to the linemen in the second, fourth, sixth and eighth cabins—the only cabins that were manned after 1925—to look out for Lillian, who would be walking north along the trail they knew so intimately. As she reached each cabin, the men tapped out a return message to Cox to say that she had come and gone safely.

In northern BC the long days of midsummer would have allowed Lillian to cover great distances in one day, but this trip could not have been easy. Even though the Telegraph Trail from Hazelton to the Yukon border offered an established route, it was really no more than a rough mule trail through hundreds of miles of mountains, valleys and rough terrain. Of course, it was never intended for use as a walking track. It was constructed for the use of the men who repaired the line and for the annual pack trains delivering provisions to the telegraph cabins, although after it was established, certain sections of it were also used by First Nations hunters, trappers and some big-game hunters.[3] Lillian would have had to ford creeks, clamber over rock falls, climb through narrow passes and cross rivers. On a good trail she walked fast, but in these conditions she probably made no more than 10 miles (16 kilometres) a day.

Lillian used up a lot of calories walking eight or more hours a day up and down mountains and fording streams along the way, but even though she must have purchased some supplies in Hazelton, her pack could not hold a month's worth of food. By most accounts she carried no more than the basic fare of bread and tea, though she must have had some way to boil water for her tea and perhaps carried a small pot or kettle in her pack. This meant, of course, that she made herself a

fire each night when she was on the trail. There is no evidence that she ever caught fish or small game, though they were plentiful throughout the area and other Telegraph Trail hikers recount fishing, trapping or shooting their food. Instead, Lillian reported eating berries, and fortunately they would have been in abundance in summer and well into the fall. She could have found plenty of huckleberries, bush cranberries, soapberries, bear or thimble berries and saskatoons. It is also known that she accepted meals from people she met on the way, and it is certain she would not have survived without this help.

As she called at each telegraph cabin, she would have begun to understand Constable Fairbairn's request that she report to the men along the line. The food, shelter, company, encouragement and human contact she received at these cabins must have helped to keep her going. In fact, the telegraph men with their wood cookstoves and shelves of foodstuffs would have been critical to her survival.

The telegraph men chatted back and forth over their wire to check in with each other and pass on messages, and they, of course, passed on news of Lillian's condition and her pace as she walked her way north from Hazelton. They began taking turns to meet her on the trail halfway between the cabins. This involvement helped to make Lillian's progress an interesting story

not just for the linemen but for the area newspapers as well, because they used the telegraph to send and receive stories. It would have been natural that the *Whitehorse Star* and other area newspapers would pick up the story of the woman who walked the Telegraph Trail. Amazingly, there are no accounts of her complaining even when she was exhausted to the point of collapsing. She apparently accepted the physical and mental hardships without a word of complaint. She kept up with the winter-hardened telegraph operators and linesmen of the Yukon Telegraph, and they must have respected her for that and been spurred on to help her.

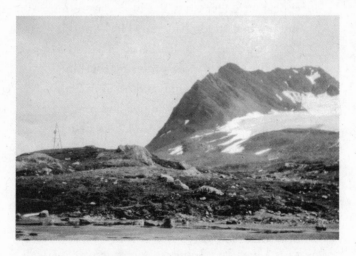

Location of Cabin Eight on the Telegraph Trail. The tower for the line can be seen in the distance. BC ARCHIVES B-01318

By the time she reached Cabin Eight, 150 miles (240 kilometres) from Hazelton, it was the first week in July and she was exhausted, bug-bitten, sunburned and hungry. She had been walking for about two weeks and it had been a struggle even for someone as fit as she was. Greeting her at Cabin Eight were telegrapher Charlie Janze and lineman Jim Christie, who described Lillian as being nearly incoherent upon her arrival.

Vancouver Sun reporter Donald Stainsby, in his 1963 article about Lillian, wrote:

> Janze and Christie were astonished at her appearance. Her dress and blouse were in shreds, her shoes battered. Her smooth complexion, which Fairbairn had noted in Smithers, was now pitted by the bites of mosquitoes, blackflies and other insects. The wind and sun had tanned and roughened it. The way she dropped her knapsack and slumped into a chair told the men how completely exhausted and hungry she was.[4]

They gave her food, and Janze, who thought her trip was foolhardy, tried to persuade her to stay at the cabin and rest for a few days. Tough though she was, the walk, the environment, the lack of food, and the insects had

all taken a toll, and she needed rest in order to survive the next leg of the trip. Janze warned her of the dangers of the high water and creek runoffs that she would be facing on the trail ahead. The conditions were awful and he did not want to see her risking her life, but she was determined to press on, and as was the way of the telegraph men, they were courteous and offered their guest as much assistance as possible. Janze, being the smaller of the two men, fashioned a pair of sturdy trousers

Charlie Janze, (left) with co-worker John Jensen. Janze outfitted Lillian for the trip by repurposing his own clothing. HAZELTON PIONEER MUSEUM & ARCHIVES

for Lillian using an old pair of his own. He also gave her two shirts, a kerchief for her head, a hat, a pair of boots and two pairs of socks to make the boots fit. The men were curious about her, but she did not reveal much.

Winfield Woolf, who came this way one year later, described the route after Cabin Eight:

> The scenery became more wonderful as I went on. From the eighth cabin the trail really began to climb. Above timber line for ten miles and working my way through a steep gorge along the side of a creek to its very beginning, I emerged upon a snow-covered upland plateau or pass, which at the highest point of the trail is 7,500 feet in elevation. Like giants seated in a circle around a mighty table, the smooth white heads and shoulders of encircling mountains rose a thousand feet higher than the edges of the plateau. Clouds, some white, others grey, were seething around their foreheads. Where the clouds were grey, I knew that it was snowing up there. I tried to hurry my steps in order not to get caught at such a high altitude without blankets in a blizzard. I was glad to get down in the lowlands again, even though the scenery up there seemed the most impressive of my entire trip.[5]

Lineman Jim Christie offered to escort Lillian part-way to the next cabin, and it was decided that Christie would walk with Lillian over the Nass Summit and past the abandoned ninth cabin to a refuge cabin 27 miles (43 kilometres) south of the Echo Lake station.[6] He telegraphed this information ahead and learned that line-man Cyril J. Tooley was reliev-ing the regular lineman, Bob Quinn, at Echo Lake. Tooley and telegraph operator Scotty Ogilvie, stationed at Echo Lake, expressed their willing-ness to help Lillian, but first Tooley had to head north to deal with some line trouble. Something—probably fallen trees—was preventing transmission. He cleaned up the cabin and headed north. On the morning of July 8, fifty-year-old telegraph operator Scotty Ogilvie strapped packs on his two dogs and walked south to meet Lillian and Jim Christie. They were fated never to meet.

Janze and Christie were astonished at her appearance. Her dress and blouse were in shreds, her shoes battered.

∞

Charlie Janze was still reluctant to let Lillian continue north to Echo Lake because it was spring runoff time, making it especially dangerous to cross rivers and streams. But Lillian wanted to be on her way and Janze

On the trail to the ninth cabin on the telegraph line. BC ARCHIVES B-01317

was slightly comforted by the fact that lineman Jim
Christie would accompany her part of the way. The trail
after Cabin Eight was very steep, and Lillian and Chris-
tie would have had a steady climb. The next part of the
route was above the timber line and ran alongside some
creeks,[7] but eventually Christie and Lillian got over Nass
Summit and passed the abandoned ninth cabin, stopping
at last at the refuge cabin south of Echo Lake.

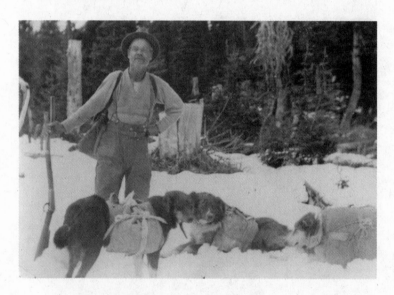

*Drysdale "Scotty" Ogilvie was on his way to meet Lillian. He
drowned while crossing the Ningunsaw River.*
HAZELTON PIONEER MUSEUM & ARCHIVES

Meanwhile, it took Cyril Tooley a few hours to correct the line trouble north of Echo Lake, after which he stopped for the night at the refuge cabin about 8 miles (13 kilometres) north of the station. From there he tried to call his partner, Scotty Ogilvie. Concerned when he received no answer, he contacted Telegraph Creek where Jack Wrathall, the wire chief, confirmed Tooley's worst fears. Ogilvie had not reported in since early that morning when he had told Wrathall that he and his dogs were leaving Echo Lake to meet Lillian Alling and Jim Christie on the trail.

The next morning, Tooley headed south past the Echo Lake station and continued on toward the refuge cabin 7 miles (11 kilometres) south of the lake. There he came upon the sad sight of Ogilvie's two dogs sitting close together on the cabin's stoop for warmth and comfort. They were still wearing their packs and they were soaking wet. He took care of the dogs the best he could and then tried to get them to go with him. When they wouldn't budge, he followed their tracks and soon found Ogilvie's tracks, too. They led to the bank of the river where there were signs of a recent collapse.

Tooley returned to the seven-mile cabin to use the telegraph. This time he reached Christie. Tooley asked him to leave Lillian at the refuge cabin and meet him on the trail the next day. Once they met up, Tooley and

Christie walked north to the Ningunsaw River, where the flooding forced them to make bridges out of fallen trees and old logs. The route was hazardous, wet and time-consuming, but they kept going, determined to find Ogilvie. Then, in one of the flooded channels as they slipped on the mud, moved water-soaked logs and heaved aside sharp branches, Tooley was shocked and saddened to discover the body of Scotty Ogilvie pushed against a big cottonwood tree. He had died the day before, July 8.[8]

Tooley later wrote: "With heavy hearts Jim Christie and I moved the body to a small island in mid-stream. Scotty had apparently struck his head when he fell in and broke his neck." Christie and Tooley wrapped Ogilvie's body in a Hudson's Bay blanket, made a makeshift stretcher and carried him to the edge of the river. There they dug a grave and buried him with a short and sad prayer.

After this long and distressing day the two men headed for the refuge cabin where Christie had left Lillian and were pleased to find that she had a roaring fire going. Tooley recalled Lillian's devastation over Ogilvie's death. "Like us," he wrote, "she was deeply moved by the tragedy."

According to the *Vancouver Sun* article by Stainsby, Lillian wanted to pay her respects.

When Tooley returned that way later with Lillian Alling, she stopped at the fresh grave, seven miles from the Echo Lake Cabin. She gathered some wild flowers to place upon it, knelt and prayed for the man she had never seen who had died trying to help her.[9]

The camp at Echo Lake was near Scotty's cabin on the Telegraph Trail. BC ARCHIVES, HP–00444

The official report of Ogilvie's death was the respon-
sibility of Constable G.E. Ashton, who was in charge of
the Telegraph Creek Detachment of the British Colum-
bia Police. On July 21 he filed the following report to
the Official Administrator at Telegraph Creek:

> Drysdale Ogilvie,
> Echo Lake, Accidentaly [*sic*] Drowned:
> Sir:-
>
> I beg to report the death of the above, who
> was a lineman at Echo Lake for the Yukon
> Telegraph Line, on July 8, 1928.
>
> The deceased was apparently looking for
> a new crossing over the Ningunsaw River
> above the usual cable crossing and walked on
> a gravel cut bank which had become under-
> mined by the river and which gave way with
> him and threw him into the river.
>
> His body was found by linemen J.F.
> Christie and C.J. Tooley about a hundred
> yards downstream from the cut bank lodged
> against a drift log and was buried nearby.
>
> His effects were brought in by J.F. Call-
> breaths [*sic*] pack train and will be forwarded
> to you forthwith. A list of his effects is
> attached herewith.
>
> Yours obediently,

G.E. Ashton
Const BC Police i/c Telegraph Creek Detach.
[Stamped July 21, 1928, Government
Agent.][10]

Scotty Ogilvie was well known in Hazelton and his
death was reported in the *Omineca Herald* of Wednesday,
July 11, 1928:

SCOTTY OGALVIE [*sic*] WAS
DROWNED IN FAR NORTH

Drysdale "Scotty" Ogilvie came to his
death while in the performance of his duty
on the Yukon Telegraph line on Friday,
July 6, 1928. Scotty has been in charge of
the cabin at Echo Lake with C.J. Tooley.
Last Friday morning he went out to do his
beat, which necessitated his crossing the
Linkinsaw [*sic*] river. The river was high
and there was a log jam. He attempted to
cross on the log jam. He did not return
to his cabin that night and next day his
partner (Tooley) and F.J. Christie, lineman
at 8th cabin, went out to seek him. They
found his body in the Linkinsaw River
Monday morning at half-past eleven.
Word was sent to headquarters through

the Hazelton office of the Dominion Tele-
graphs and authority was then sent to the
provincial constable at Telegraph Creek to
decide on the disposition of the body.

Drysdale Ogalvie was an old-timer in this
country. He was around Hazelton in the
early days of railway construction and was
known and liked by everyone with whom
he came in contact. He had a jolly dispo-
sition and was also quite an entertainer.
These qualifications made him many
warm friends, and there will be general
regret at his tragic end. He was a native of
Glasgow and was forty-six years of age. He
had been with the Dominion Telegraphs
off and on for the past ten years. "Scotty"
went overseas with the Pioneers from this
district and gave full service at the front.
Of all the boys who went overseas from
this section he was one of the few who
came back here and stayed.[11]

The men of the telegraph line were devastated by
Ogilvie's death, and since he died on his way to help Lil-
lian, it was not surprising that some of his fellow lines-
men and operators felt resentment toward the woman

who caused his death.[13] As a result, most of the subsequent reports have her simply walking away after his death, accompanied by a dog.[14]

Crossing a Stream on the Telegraph Trail

Traveller Winfield Woolf, who journeyed up the Telegraph Trail a year after Lillian, recounted his own experience crossing one of the flooded streams on the Trail:

> For a long time I stood on the bank trying to decide which was the better chance—swimming the rapids or crossing on the cable. First I attempted hanging on to the wire with my hands, but finding this impossible, I returned to the shore. Then I walked upstream looking for a place to ford. The man at the last station had presented me with a shoulder of caribou and a can of tongue. Knowing that I could not now carry these with me, I tried to throw the meat across to the opposite bank. However, it landed short. When I saw what the current did to that shoulder of caribou, I changed my mind about

attempting to ford the river. To make doubly certain, I flipped a dime I had in my pocket. The wire won. Before starting out, I sat down to eat the can of tongue, knowing I would need strength for the ordeal ahead of me. Having learned that I could not support myself by my arms alone on the cable, I wrapped my legs around it and, like a South American sloth, pulled myself across with my hands. Right over the middle of the river, my strength gave out. I was so exhausted that the temptation came to me to let myself drop. It seemed the easiest thing to do. But one look down at the white rapids and rocks below gave me the willpower to go on. On reaching the opposite shore, I was so all in that I could go no further that day.[12]

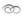

By some accounts Jim Christie gave Lillian a dog called Bruno, and since Christie was the person who took the only known photograph of Lillian with a dog, perhaps the dog in the photograph is Bruno. Lineman Cyril

Tooley, however, said that Christie's dog was called Coyote and that Christie never gave a dog to Lillian. Author Diane Solie Smith, in her booklet on Lillian Alling, says that it was Tommy Hankin, who worked at the Echo Lake cabin, who gave Lillian his black and

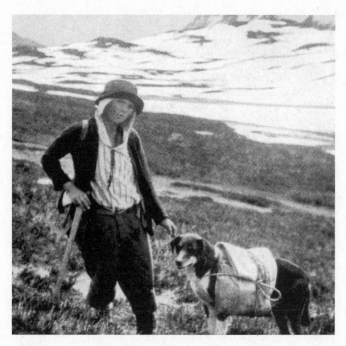

There are many contradictory tales of Lillian travelling with a dog, but it is clear from this picture that she did have a four-legged companion, at least for a while. This photo was taken by Jim Christie and was originally published in the Beaver: Canada's History Magazine, *1943.*

white lead dog, a husky called Bruno. According to Smith, Hankin told Lillian to keep the dog on a lead because trappers had left poison out for wolverines. By the time Lillian reached Nahlin, she no longer had a dog. It had either died or run away. Smith wrote that Bruno died at Iskut River, probably after eating the lethal bait.

... the story of the dog took on a strange life of its own.

When questioned later by people in the Yukon about her dog, Lillian did mention that she had briefly owned a pack dog that had drowned. Diane Solie Smith makes a good point when she says: "Maybe she wished to hide the mistake of letting him roam loose to sample poisoned bait."[15]

Clearly, Lillian did have a dog for a short time. She got it somewhere around Cabin Eight or the Nass Summit and no longer had it by the time she reached Nahlin. But bizarrely, the story of the dog took on a strange life of its own and a number of erroneous reports have Lillian travelling through the Yukon and Alaska carrying a stuffed dog perched on the top of her backpack. Even Donald Stainsby, who did such a good job of tracking down the men who met Lillian so many years ago for his otherwise reliable *Vancouver Sun* article of 1963, perpetuated the myth of the stuffed dog. When Lillian arrived in Atlin, wrote Stainsby,

[S]he strode into town alone, her stick in her hand, and her knapsack on her back—and atop her pack the lightly-stuffed hide of Bruno. Where or how the dog died are not known. But the hide, stuffed with grass, stayed with her as long as there is a record of her because, as she is reported to have told a hotel keeper in Atlin, "He was my only friend and he will always remain with me."[16]

Stainsby also wrote that when Lillian later launched herself down the Yukon River, the stuffed hide of Bruno was on the top of her provisions, inside the raft. Writer Edward Hoagland perpetuated the ridiculous stuffed-dog story in a book published in 1969: "They gave her a puppy, which died, so she skinned it and stuffed it with grass, continuing to carry it under her arm."[17]

The remnants of an abandoned cabin near Telegraph Creek. BC
ARCHIVES A–08314

Chapter Six

Telegraph Creek to Atlin

From Echo Lake, Lillian walked north, passing two named cabins—Iskut and Raspberry—as the trail turned northwest toward the village of Telegraph Creek. She had now walked 350 miles (560 kilometres) through the wilderness from Hazelton.

Lillian's very brief stop in Telegraph Creek was remembered—and wildly embellished—in 1930 when a California couple, Ruth and Bill Albee, visited the little settlement. When the Albees talked to the locals, they were given a remarkable tale about her:

> The talk veered to a Russian woman of about thirty-five, who, with her little fox-terrier, had stopped briefly at Telegraph Creek the previous fall, and whose mysterious behaviour in shunning everyone

there still formed a juicy morsel of gossip among people starved for excitement. Except for her little dog, she seemed utterly friendless.

Taken together, the rather nebulous bits of description volunteered by our hosts left no doubt as to the woman's physical charm. She was a small, slender brunette with clear-cut Russian features, nervous hands and jet-black hair coiled beneath the handkerchief she wore, peasant-like, on her head. They thought it doubtful she had come clear from San Francisco, as some said. Yet the bedraggled appearance of her expensive breeches, leather jacket and worn hiking boots certainly pointed to endless miles afoot.

But what had impressed everybody even more than her startling beauty was the fanatical gleam in her black eyes—a gleam which brooked no fooling.

After a few days, with winter at hand, she and the dog had silently started north along the Telegraph Trail, leaving a seething mass of rumours behind.

Some were sure she was a White Russia refugee in a desperate dash to rejoin her husband by crossing over from Alaska. Anyhow, they pointed out, she was headed that way. Others, remembering her constant, furtive glances, were equally certain that she was being pursued by spies. The whole yarn sounded so fantastic that there came times in the telling when we wondered if Telegraph Creek itself were a bit "touched."[1]

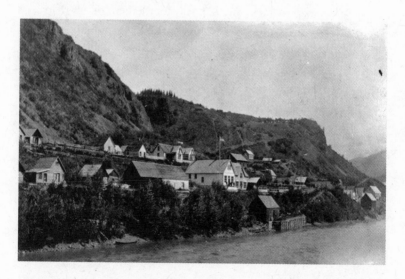

Telegraph Creek in the early 1900s. BC ARCHIVES A-01569

Telegraph Creek

Telegraph Creek, in the territory of the Tahltan First Nation, was established as a major supply centre for the Collins Overland Telegraph. However, the Collins Telegraph was abandoned long before it got that far. The town enjoyed a brief heyday during the 1898 Klondike gold rush, but when it was over, it shrank to a small, quiet village again. It was finally connected via telegraph when the Yukon Telegraph was completed in 1901. Telegraph Creek, in 1928, was a settlement of less than one hundred people comprised of a double row of stores and houses on terraces leading down to the Stikine River. They included a Hudson's Bay building, Provincial Police station, some guide outfitters and, of course, a Yukon Telegraph office.

Rumours of marriage in Telegraph Creek

T.E.E. (Ern) Greenfield, the RCMP officer who assisted Provincial Police Constable George Wyman with Lillian's arrest in September 1927, later insisted that Lillian made it only as far as Telegraph Creek, where she settled down.

One year later I received a letter from Lillian Alling at Telegraph Creek thanking me for delaying her a year from meeting her "beloved." She had reached Telegraph Creek through the Cariboo from Vancouver and had travelled at nights through the Bulkley Valley and Hazelton. Beyond Hazelton she was the guest of the telegraph linemen every forty miles. Finding her beloved had departed from Telegraph Creek, she wrote me that she had fallen in love with a kindly settler there and had married him.[2]

But Lillian had not lingered long in Telegraph Creek. She was soon on her way north again, still following the rough trail under the telegraph line. Thirty-eight miles (61 kilometres) beyond Telegraph Creek, she passed by the Shesley Station, and after another 47 miles (75 kilometres) she was at Nahlin. Joe Hicks, the lineman at the Nahlin telegraph cabin, kindly turned it over to her so she could sleep under shelter. Speaking with the Albees two years after Lillian's visit, he said, "Mighty glad you brought your husband along. I'm sick of getting turned out by lone women just so's they can sleep in here themselves."[3]

Stories of a Russian Countess

Dietger Hollmann, an amateur historian who followed Lillian Alling's trail to the Atlin area in the late autumn of 1970, met with Jim Grant, owner of the Highland Glen Muncho Lodge. Grant told Hollmann that he believed Lillian had been a Russian countess. Hollmann also met old-timer Andy Bailey who, in 1928, had been working the Ruby Creek mine, and Bailey gave Lillian an even loftier title: he was convinced that she was the Russian tsar's last daughter. Hollmann said that on another of his trips to Atlin he met some prospectors and trappers in their eighties and nineties who spent their summer days sitting in front of their small houses and talking to visitors. Yes, they said, they knew the Russian princess. One of the men even claimed to have exchanged a few words with the petite young woman. "A tough one," he said.[4]

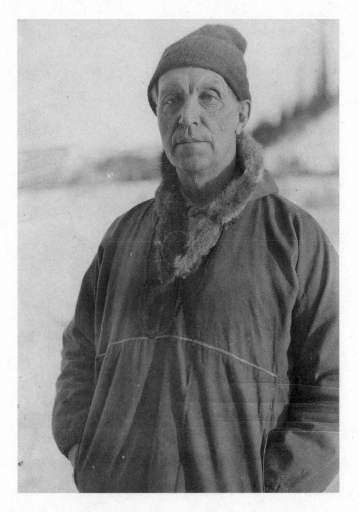

Joe Hicks was the lineman at Nahlin until he retired in 1932.
ATLIN HISTORICAL SOCIETY

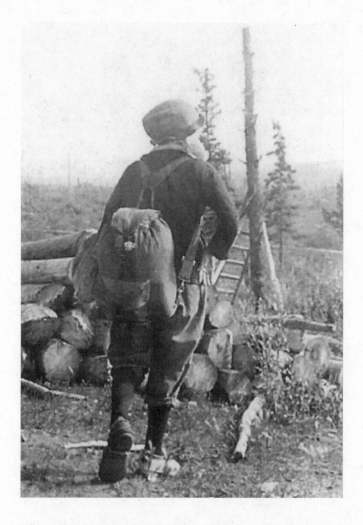

Photo taken by Marie Murphy. ATLIN HISTORICAL SOCIETY

Lillian left Nahlin, and just about 30 miles (48 kilometres) south of Atlin she walked across the O'Donnell River using Nate Murphy's wooden foot bridge. It was Nate's wife, Marie, who took two of the few known photographs of Lillian Alling. These photos show a young woman in worn clothes. Atlin author Diane Solie Smith said of the photograph that "it is impossible to look at that old black and white image and doubt that Lillian Alling would reach her destination."[5] Although Marie Murphy was known as a hospitable hostess and kept an extensive diary, she made no mention in it of Lillian visiting the Murphy homestead or of providing her with a meal or a night's lodging.

When Lillian left the Murphys, she headed for the picturesque town of Atlin. The *Whitehorse Star* later reported, "Upon her arrival at Atlin she was in a bad way for footgear, and there she purchased a pair of canvas shoes with rubber soles."[6] Atlin was Lillian's last stop in British Columbia, but the newspaper does not mention how long she stayed there.

Having purchased her shoes, Lillian apparently wasted no more time in Atlin. Following the lakeshore and then using the telegraph line to guide her, she crossed the 60th parallel into the Yukon Territory.

Atlin

The Atlin gold rush came to the Pine Creek area near glacier-fed, 85-mile-long (137-kilometre) Atlin Lake in 1898 after two miners, Fritz Miller and Kenneth MacLaren, on their way to the Klondike, discovered gold there. It wasn't long before some ten thousand prospectors and miners were hauling tonnes of supplies over mountains and across the lake to a new settlement on the eastern shore called Atlin. Those first inhabitants of the town survived the harsh winters in tents and rough wooden structures. Initially the strike was believed to be in the Yukon, and it took some time to discover that the border between the Yukon and BC ran north of it. Gradually the number of miners decreased, although the mines in this area are still producing today.

Tourism began in 1903, when hunters and fishermen arrived from as far away as Europe. Starting in 1917, the MV *Tarahne* provided lake cruises to the massive Llewellyn Glacier, which is believed to be the main source of the Yukon River. In the early 1920s, when Atlin had become established as an exotic destination for tourists,

the White Pass and Yukon Railway built a three-storey inn to cater to them. Unfortunately, tourism decreased during the deprssion years and the population sank to a little more than a hundred.

In April 1928, the first air mail came to Atlin. T.G. Stephens piloted the *Queen of the Yukon*, a Ryan monoplane and sister ship to Charles Lindberg's *Spirit of St. Louis*, landing it on the frozen lake. Although the residents didn't realize it at the time, the arrival of this first mail plane meant that soon there would no longer be any mail delivered by dogsled.

This is one of the few images of Atlin in the 1920s. ATLIN HISTORICAL SOCIETY

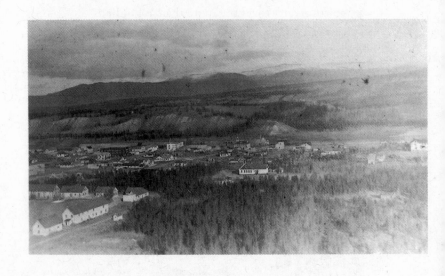

Panorama of Whitehorse, c. 1920. DAWSON CITY MUSEUM 1995.
345.28

Chapter Seven

Tagish to Whitehorse

*I*t was August 24 when Lillian finally arrived in Tagish, her first stop in the Yukon.[1] In the long days of August with a good trail underfoot, by averaging nine hours of walking per day she should have been able to travel the 70 miles (113 kilometres) north from Atlin in just two days. But Winfield Woolf, taking the same route in 1929, indicated that this was actually a very difficult stretch of the trail. "Without any trail at all," he reported, "I went on to Tagish—climbing over windfalls with logs criss-crossed almost every foot of the way."[2]

In spite of her efforts to keep a low profile, Lillian Alling had by now become something of a celebrity across the north. Since the population of the entire Yukon Territory was, according to the 1921 census, just 4,157 and comprised of twice as many men as women,

this lone woman walking to Siberia could not escape notice, and the newspapers picked up even the smallest details of her story. For example, on August 31, the *Whitehorse Star* reported that "at Tagish she was taken over the river by Ed Barrett."[3] The river in question was the Six Mile and Ed Barrett was the owner of the Tagish Trading Post (not to be confused with Tagish Post, which was farther south). He made a portion of his living by ferrying travellers across the river in his boat.[4]

Lillian seems to have spent the night at Tagish but wasted no time on the tourist sights there as she embarked on the 19-mile (30-kilometre) trek to Carcross early the next morning. Although it is southwest of Tagish, it was the logical way to go: there was no direct trail north from Tagish to Whitehorse, but a wagon road had been built over the traditional foot trail between Tagish and Carcross, and a well-travelled road led from there to Whitehorse. The *Whitehorse Star* reported on her progress in its August 31 edition:

> On Saturday last [August 25] she arrived
> in Carcross and had a meal at the Caribou
> Hotel. Mr. Skelly frankly admits that he
> had never seen or heard of her before; nor
> was he able to get any information from
> her. She left Carcross the same afternoon,
> travelling in a northerly direction.[5]

Tagish

The settlement of Tagish (a Tagish Athapaskan word that means "fish trap") sits on the banks of the Tagish River, also known as the Six Mile River, which connects Marsh and Tagish lakes, part of the Yukon River system. The original settlement in this area, a Northwest Mounted Police outpost, was 3 miles (5 kilometres) south of the present one on the east side of Tagish Lake and was called Fort Sifton to honour federal Minister of the Interior Clifford Sifton. This outpost was established during the Klondike gold rush to enable the police to register gold seekers and conduct safety inspections on their gear. After the gold rush, the main settlement was established at its present location on the riverbank and became a station on the Yukon Telegraph line.

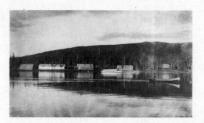

Tagish post at Six-Mile River. YUKON ARCHIVES, VOGEE COLLECTION YA 175

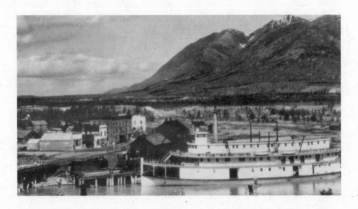

Carcross was an active boat building centre and served as communication point for the Yukon. YUKON ARCHIVES, GLENN D. BLANKE COLLECTION 2006/129 #10

The Mr. Skelly referred to in the *Star*'s article was probably Gilbert Skelly, owner of the Kluane Roadhouse, but he may have also been running the Caribou Hotel's restaurant as the owner, Bessie Gideon, was in failing health. As the cost of importing food to the Yukon was very high, Lillian's dinner in Carcross would have cost as much as a dollar. She may also have bought provisions at Matthew Watson's General Store, which was next door to the Caribou Hotel.

Although the *Star* reported that Lillian left Carcross after her meal there on Saturday, August 25, and that she was "travelling in a northerly direction," she did not travel very far that afternoon. Instead she apparently

Carcross

Carcross was originally known as Caribou Crossing because of the large herds of woodland caribou that crossed the river here on their annual migrations. At the end of the nineteenth century the settlement became a major stopover for gold miners on their way north to the Yukon goldfields, as well as south to Atlin for that area's gold rush. The name of the town was changed in 1904 to eliminate confusion with towns with similar names in the Yukon and British Columbia.

The Caribou Hotel, established in Carcross in 1898, is the oldest continually operated hotel

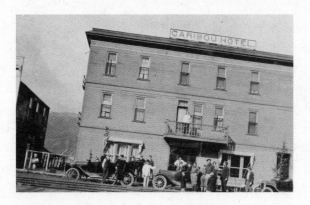

The Caribou Hotel. YUKON ARCHIVES, BUD AND JEANNE (CONNOLLY) HARBOTTLE FONDS #6090

in the Yukon; it is still open for business in the summer months. Edwin W. and Bessie G. Gideon took over the hotel in 1908; it burned to the ground a year later and they built a new one on the same site. It featured hot running water and real bathtubs. They acquired their hotel's mascot, Polly (which happened to be a male parrot), in 1918 after its owner was drowned in the sinking of the SS *Princess Sophia*. The parrot was known for its foul language, and often when female visitors came, a cloth was thrown over its cage to prevent it from swearing. It lived until 1972. After Edwin Gideon died in 1925, his wife operated the hotel until her death in 1933.[6]

looked for a place to spend the night. It was now nearly the end of August and the daylight hours were much shorter. Already the nighttime temperatures would be dropping, and if she was still sleeping rough and only wearing the clothes that Charlie Janze had fashioned for her back at Cabin Eight on the Telegraph Trail, she would have had to make a fire each night or find an empty cabin. Her alternative was paying for accommodation in a roadhouse or private home, and up to this point she seems to have avoided paying for accommodation whenever possible.

Wherever she stayed the night of August 25, she delayed her departure the next day because she was next seen just north of Carcross on Sunday afternoon. According to the *Whitehorse Star:*

> On Sunday afternoon Mr. and Mrs. George Wilson overtook her between Carcross and Robinson and she rode in the car with them as far as Robinson, where she got out, saying that she was going to rest a while. Beyond saying that she was going a little north of Whitehorse, she had very little to say to Mr. and Mrs. Wilson. She did say, however, that for a part of her journey she had a pack dog but that he was drowned in crossing a stream. When warned that she would have streams to cross between here and Dawson, she said that she would cross them on a log.[7]

Robinson was only 20 miles (32 kilometres) north of Carcross, and Whitehorse was just 20 miles beyond that, but according to the *Star,* Lillian did not reach Whitehorse until the evening of Monday, August 27. It seems apparent, therefore, that when she told the Wilsons that she was "going to rest a while" at Robinson, she planned to find some kind of overnight lodging there. The tiny

settlement of Robinson memorialized "Stikine Bill" Robinson, who had been hired by the White Pass and Yukon Railway to lay the grade and manage delivery of construction materials and supplies from the White Pass to Whitehorse. The company had named a flag station in his honour, and a roadhouse was established nearby. It began as one log cabin lodge, a saloon and three tents but it gradually grew into a small townsite. It was abandoned in 1915 after the decline of mineral discoveries in the area. By the time Lillian came that way, she would have had her pick of the abandoned cabins.

The next report from the *Whitehorse Star* announced that, after weeks of anticipation, Lillian Alling had actually arrived in Whitehorse.

> A woman giving the name of Lillian Alling walked into town Monday evening [August 27] and registered at the Regina Hotel. Lillian was not given to much speaking, but as near as can be gathered from information she gave at different places she had walked from Hazelton to Whitehorse, a distance of about six hundred miles, following the government telegraph line all the way ... She told Mr. Erickson that she did not have very much

money, and she seemed to be conserving
her resources but paying her way.[8]

The owners of the Regina Hotel in August 1928
were Olaf "Ole" Erickson and his wife, Kristina, both
born in Sweden, who had bought the hotel just a year
earlier. At the age of fifty, Erickson knew that owning
and running a hotel, no matter how difficult the chal-
lenges, would provide a better income for his family
than relying on the irregular returns from gold mining.
The Ericksons gained a reputation as excellent hosts and
providers of good food; their hotel also had an air of
respectability because rowdiness was not tolerated.[9]

The Ericksons' children, daughter Gudrun, also
known as Goodie, and son John, continued to run the
hotel until the 1990s. Goodie, whose married name is
Sparling, was born in 1926 and grew up in the family
hotel. She was two years old when Lillian stayed at the
Regina, but she recalls her parents talking about Lil-
lian's visit there. She remembers her father describing
her as "a very slight woman" and saying that he "thought
she was nuts." Goodie thinks she recalls a photo of her
"wearing jodhpurs" and that she was shown her signa-
ture in the hotel registry.[10]

Lillian began the 270-mile (434-kilometre) trek
to Dawson City on August 28. The *Whitehorse Star,* in
announcing her departure, noted that:

She had no means whatsoever of killing wild game and was carrying very little food. If she knows her destination, she is not telling, but she started north from Whitehorse on the Dawson trail Tuesday forenoon.[11]

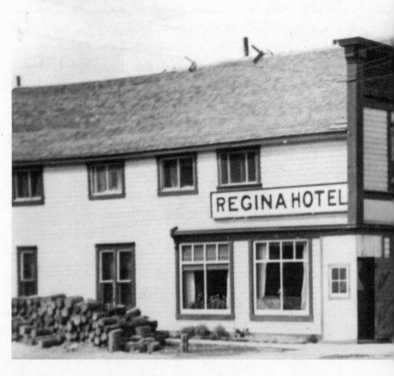

On August 27, 1928, Lillian stayed overnight at the Regina Hotel in Whitehorse. Olaf and Kristina Erickson were her hosts. YUKON ARCHIVES, ROBERT HAYS FONDS, #5716

The *Star* also told its readers that, when Lillian left on that August morning, the only provision she carried was a loaf of bread, "which she had cut in three pieces as she said she was not carrying a knife."

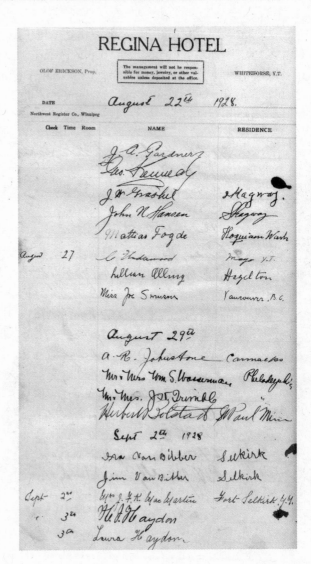

Lillian's signature (seventh from the top) appears on the August 27th, 1928, register of the Regina Hotel in Whitehorse. YUKON ARCHIVES, ERICKSON FAMILY FONDS, 2003/83, MSS 400 FILE 12

138

Whitehorse

Whitehorse was the traditional home of the Kwanlin Dun First Nation. Non-Native settlement began during the early days of the Klondike gold rush, and grew to a flood of prospectors and miners after the town became the northern terminus of the White Pass and Yukon Railway. As it was also the upper limit of navigable water for the steamboats on the Yukon River, about two thousand people had settled there before the gold rush was over in 1900.

A short-lived copper boom in the nearby copper belt ended in 1920. The whole area was then promoted as a hunting and fishing tourism destination, and Whitehorse became an outfitting and takeoff base. However, there had been a steady outflow of population since the copper boom ended, and the town's population slid to 754 persons by the beginning of World War II.

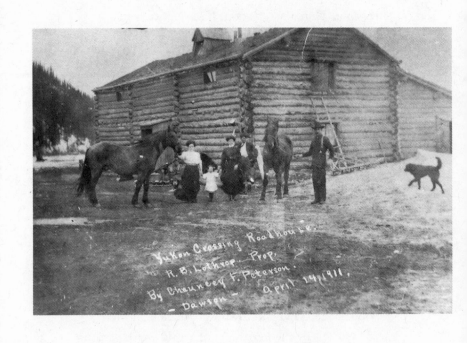

The roadhouse at the Yukon Crossing in 1911. DAWSON CITY MUSEUM, 1994.264.1

Chapter Eight

The Road to Dawson

The "new government road" that was built to connect Whitehorse and Dawson in 1902 was actually more trail than road, and it was divided into five separate sections by the Takhini, Yukon, Pelly and Stewart rivers. But by the 1920s, the Yukon government was having difficulty maintaining roads, and this route was in very bad shape.[1] Between the poor condition of the road and fewer daylight travelling hours, Lillian's walking speed was reduced from a high of 30 miles (48 kilometres) per day to a new low of just 10 miles (16 kilometres). It was also much more difficult to find shelter for the night. Laura Berton, in her book *I Married the Klondike,* described the route at this time:

> Many of the roadhouses, which in the old days had been spotted every twenty-two

miles along the winter road, were closed. Passengers now had to provide their own lunches and these were eaten in the open after being thawed out by a bonfire on the side of the trail.[2]

When Lillian could not make it to a roadhouse or where there wasn't one to be found, occasionally she may have come across an abandoned cabin, a few of which were still fully equipped all these years after the Klondike gold rush. As freight rates were so high, it had been impractical for most of the miners to ship their household goods out, so they had just abandoned everything, and for many years travellers could find bedding, furniture, curtains, cooking utensils and more. However, by the late 1920s, the years and the weather had taken their toll, and most of the houses had lost their contents and structure to either passersby or the winter snows.

This late in the year it was also impossible for her to live off the land. By September the fresh berries at the roadside would have been eaten by birds or bears or would have dried up in the summer sun. She had no traps or snares to catch small game, or fishing equipment— although the rivers teemed with record-sized trout.

The *Whitehorse Star,* which had begun referring to Lillian as "the Mystery Woman," caught up with her progress just 22 miles (35 kilometres) north of Whitehorse

where the new government road was bisected by the Takhini River. There she met James Adams, the keeper of the roadhouse at that point, who "had misgivings about extending the usual courtesies." The "usual courtesies"[3] in this case meant taking her across the river in his boat. Fortunately, he appears to have quelled his misgivings, because the newspaper's next report, delivered to its avid readers on September 7, placed her northeast of that point:

> The last report of the mystery woman was that she was seen by H. Chambers some distance east of Tahkinna [*sic*] several days after she left here. Mr. Chambers offered to give her a ride to the fork of the road but she declined.[4]

Mr. Chambers was probably Harry "Shorty" Chambers, vice-president of the Whitehorse Board of Trade.

There were no further reports until she reached Carmacks, a settlement at the junction of the Yukon and Nordenskiold rivers.[5] The *Whitehorse Star* reported that "the mystery woman passed through Carmacks but she maintained her silence."[6] However, the paper noted that "she made some meagre purchases"[7] before she continued her journey. It was now about September 10 and she was 112 miles (180 kilometres) north of Whitehorse,

but she still had 225 miles (360 kilometres) to go to reach Dawson City.

A few days after leaving Carmacks, the paper reported that she had travelled another 30 miles (48 kilometres) north and arrived at Yukon Crossing "where she allowed H.O. Lokken to put her over the river. She still has the Pelly and Stewart rivers to negotiate."[8] Harold O. Lokken had arrived in the district during the gold rush years, had served as head linesman on the Yukon Telegraph for many years and was still an active prospector. Lokken also acted as the local ferryman.

By mid-September, Lillian had passed through Pelly Crossing where, the *Whitehorse Star* informed its readers, "A. Shafer" had taken her across the Pelly River in his boat. This would have been Alexander Shafer who, with his wife Margaret, ran the Pelly Crossing roadhouse.[9]

Then, according to the *Dawson News*, Lillian walked the 40 miles (64 kilometres) from Pelly Crossing north to Stewart Crossing on the shore of the Stewart River, arriving near the end of September. By this time she had walked some 252 miles (405 kilometres) from Whitehorse.

At Stewart Crossing, she bought or was given a type of raft known as a "float-me-down," composed of whatever logs and branches happen to be at hand. It was on

this contraption that she floated down the Stewart River until she reached the settlement known as Stewart City, which lies at the junction of the Stewart and Yukon rivers. At this point a storm blew up and it became too dangerous to launch her raft onto the Yukon River, and she was forced to stay on shore for a few days. The *Whitehorse Star* noted that "T.A. Dickson's survey party was camped [there] and the boys cared for her for three days during a bad storm."[10] Thomas A. Dickson (1856-1952) was one of four brothers who had all been members of the North West Mounted Police. Thomas Dickson had served with the Tagish detachment in 1898 and after leaving the force had become the Yukon's first big-game guide.[11]

Lillian's choice of transportation was not an unusual one for this region. With no roads and few trails, but with plenty of fairly navigable rivers, locals and visitors alike used boats and rafts of all kinds as a main form of transportation. "When the ice at last cleared," wrote Archie Satterfield in his book *After the Gold Rush*, "they launched an armada of steamboats, canoes, rowboats, skin boats and rafts called 'float-me-downs' that they sold for lumber in Dawson City."[12] Even children were trusted to float down the river safely towards Dawson. Alex Van Bibber, who as an adult was a well-known big game guide and outfitter, described his trip down the river from Pelly Crossing toward Dawson to attend boarding school at St. Paul's Hostel:

To get to school in Dawson in September, we used a raft. My dad wouldn't see us paying for tickets on a sternwheeler when the river ran in that direction anyway. So he built a raft and loaded us on it with a bunch of vegetables. Before he pushed us out into the current, the old man would give us some advice. "If the raft starts to get water-logged, just pull into a drift pile and tie a few more logs on to give it some buoyancy. It'll keep floating that way." We were still pretty young and scared of bears, so most of the time we would sleep right on the raft. When we did spend the night on the beach, we'd make sure we were real close to that raft, and if we heard any noises, we didn't waste any time poling it out into the river again. All us kids would just huddle together in an old broken down sleeping bag that we'd sell or just throw away after we got to the other end.[13]

Alex was one of the sixteen children of Ira Van Bibber, who was originally from West Virginia, and his wife, Eliza, affectionately known as "Short." She was a Tlingit of the Crow clan and was originally from Juneau, Alaska. They owned two roadhouses in Pelly Crossing.

Floating down the river by raft was not an unusual choice. The Van Bibber children went to school in Dawson by raft, floating down the Yukon River by day and sleeping on the raft at night to avoid bear encounters.
YUKON ARCHIVES, VAN BIBBER FAMILY FONDS, 87/80 #75

But Lillian was not destined to continue her journey on her "float-me-down" all the way to Dawson City. According to an article written by Irving J. Reed for *Alaska Life* in June 1942, when she showed up at the confluence of the two rivers on her roughly hewn home-made raft, it looked "so dangerous that a sourdough along the bank took pity on her. He gave her his boat so that she might continue more safely her journey from the mouth of the Stewart, down the Yukon River to Dawson."[14] The fact that all further sightings of her

on her river travels place her in a boat rather than on a raft suggests that this was probably how and where she acquired it.

By now readers of the *Whitehorse Star* and the *Dawson News* were becoming anxious for word of the "mystery woman." The weather had been blustery ever since the storm that had held Lillian up for three days at the mouth of the Stewart River. But most of them knew exactly how long it took to float down the Yukon from there to Dawson, and she was definitely overdue. Where was she? The *Dawson City News* reported:

> Lillian Alling, "mystery woman" hiker, who reached Ogilvie Monday night [October 1], and who pulled out by small boat from that island, fifty miles above [south of] Dawson, the following day has not yet reported here.[15]

Then on October 6 the *Dawson News* was able to report that all was well. Lillian had been "held wind-bound at Swede Creek for two days" and then "finally set sail Friday morning [October 5]."[16] As Swede Creek is just a few miles from Dawson, readers could expect her to arrive in Dawson any moment. And she did.

The *Dawson City News* then recapped Lillian's journey for its readers:

8 The Whitehorse STAR, 90th Anniversary Edition, Saturday, June 16, 1990

LILLIAN AILING

The MYSTERY WOMAN

By JOHN PICTON
© The Toronto Star Syndicate

No one took any notice of the young woman who sat in New York's public library day after day.

While other people's requests for references material differed, hers was always the same - maps. She wanted every map to North America they had on file.

It was the first act in one of the most amazing journeys the world has known.

Painstakingly, the woman would run her course hands over the pages, copying the main features of the landscape in pieces of paper.

From the lush green of New York state, she traced a line across to the forests of Minnesota, up into the Canadian Prairies, through the mountains of British Columbia. And then, with a frown, she'd study the bleak route north.

Her dark eyes would narrow as the changing colors on the maps indicated the increasingly rugged terrain. It certainly wouldn't be easy, she must have thought. Yes, she kept tracing the Yukon, across Alaska. Yes, it was the route she would have to take.

Her fingers stopped only when they had reached the shore of the Bering Strait. There only a tantilizing fraction of an inch away, was her goal - Siberia. But that fraction represented 50 miles of frigid water.

How was she to traverse that? It was, she resolved, a problem she would solve when she came to it. Now, there were

more immediate things to think about.

Pulling her shawl around her frail shoulders and tucking whisps of dark hair into her headscarf, she returned her maps to the desk and left the library for the last time. It was spring in the year 1927.

Soon after, Lillian Ailing walked unnoticed out of New York, a figure less than five feet in height and weighing about 100 pounds, her stride reflecting a degree of determination unsurpassed in human endeavor.

Later, it would become known that she was 25, that she had been in service in a New York family, and that she hated North America.

Little else is know about the mystery women, except that

she is thought to have been from Russian and would tell anyone who asking where she was heading "I go to Siberia!"

But even in that there is a mystery, for T.E.F. Greenfield, an RCMP office who met her on her 6,000 miles (9,700 kilometre) journey, claimed 48 years later that she carried a

message to the police telling them of his surprise visitor.

Const. George Wyman hiked the 33 kilometres from Hazelton out to the cabin and later recorded his meeting with Lillian.

'I was so surprised to see that woman there,' he said.

LILLIAN AILING with dog Bruno.

The "Mystery Woman" as the Star saw her

August 31, 1926
Whitehorse Visited By
Woman Hiker

A woman giving the name of Lillian Ailing walked into town Monday evening and registered at the Regina Hotel. Lillian was not given to much speaking but as can be gathered from information she gave at different places she had walked from Hazelton to Whitehorse, a distance of about six hun-

the Dawson trail Tuesday forenoon.

September 7, 1928
The Mystery Woman

The last report of the mystery woman was that she was seen by H. Chambers some distance east of Takhinsa several days after she left here. Mr. Chambers offered to give her a ride to the fork of the road but she declined.

of the "Mystery Woman" in the Whitehorse Star, the people of Dawson have been looking forward with an unusual degree of curiosity for her arrival there. She had been reported at different points enroute from Whitehorse to Dawson. Jimmie Adams had misgivings about extending the usual courtesies at Takhini; further down the trail she had declined an invitation to a ride with President Chambers; so Carmacks she made some meagre par-

She braved the perils of the overland trail through the Yukon arriving safely at Stewart Crossing from which point she made the balance of the journey to Dawson by small boat. Unaccustomed to oars and unfamiliar with the tortuous channel of the mighty Yukon, forced to endure the biting wind and frost of an impending winter, the woman traveler spent the most trying and uncomfortable hours of her long trip in making the last lap, from Stewart City to Dawson.[17]

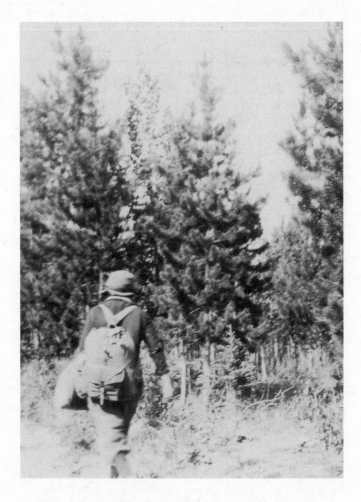

Whether Lillian was hiding from the camera or just camera-shy, it is clear she was not going to take the time to pose. Detail of photo taken by Clifford Thompson. DAWSON CITY MUSEUM 1991.46.2

Dawson City

*L*illian Alling, having left Whitehorse on the morning of August 28, finally made it to Dawson City on Friday, October 5, and the *Whitehorse Star* reported that "practically all of that time she must have slept in the open."[1] The next day the *Dawson News* announced her arrival to the residents of that former gold rush town who had been eagerly anticipating her arrival.

> Lillian Alling, "mystery woman" hiker, reached Dawson by small boat Friday fore-noon, thereby completing one of the most hazardous and unusual overland treks for a woman that has ever been recorded in the Northland … [she] finally completed the last lap of her long journey shortly after 11

o'clock when she moored her frail craft to the south of the old Klondike Mines Railway bridge. Word that the long-expected woman adventurer had arrived here spread quickly, and few Dawsonites who saw the short, slight figure as she stepped briskly down Fifth Avenue into the center of town, where she sought food, but realized that this was the "mystery woman."[2]

Thirty-seven years later the moment of Lillian's arrival in Dawson city was still fresh in the mind of former *Dawson News* reporter Archie Gillespie when he told the *Yukon News*,

> I was a reporter on the *Dawson News* at the time and happened to be walking along Front Street when I first noticed the tiny craft drifting down the Yukon River. It was unusual for a boat to be seen heading into Dawson at this late season of the year. My curiosity led me to walk down to the beach to see who was landing. It was hard to believe that anyone would be making the cold river journey in an open boat long after navigation had closed.

The last steamers had left for the south and few small craft had ventured out on the wind-swept river. Most of the flotilla of small boats had been pulled up on shore and anchored for the winter. So it was all the more surprising when a small rowboat rounded the bend above Dawson City and drew into the shore-line. Out of the small boat, which was no bigger than a skiff, stepped a small, thin woman, fatigue showing in every line of her haggard face, her tired eyes and the stoop of her slight shoulders.[3]

Local banker Clifford Thompson was also on hand that day and took two photographs of her shortly after she docked her boat:

I arrived in Whitehorse in May 1928 to work in the Canadian Bank of Commerce during the summer and to go on to the Dawson Branch in September of that year. During that summer we heard reports about Lillian Alling, and about August she appeared in Whitehorse. I saw her in Whitehorse and she was very tanned and dark coloured. I heard she

had left Whitehorse before I embarked for Dawson City in September. Mr. J.D. Skinner of the *Whitehorse Star* requested me to send him a weekly news bulletin by telegraph about any interesting news in Dawson and he particularly asked that I look out for the arrival of Lillian Alling in Dawson. One morning as I was going to open up the Bank, I saw Lillian Alling coming up the ferry slip, which in those days ran alongside the Bank. To the best of my knowledge this was early in October

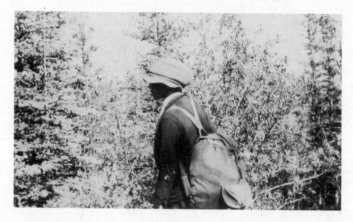

This and the photo on page 150 are the last known images of Lillian. Detail of photo taken by Clifford Thompson. DAWSON CITY MUSEUM 1991.46.1

and I reported this news to Mr. Skinner. I got my camera and took two pictures of her, which I have in my possession. I endeavoured to have a talk to her but she became very angry and refused to talk.[4]

Clifford Thompson also noted that as soon as Lillian arrived in Dawson City, she checked in with the police.

She was headed for the RCMP barracks and I later confirmed thru a member of the RCMP that she had reported in that morning. Later on in October I was told

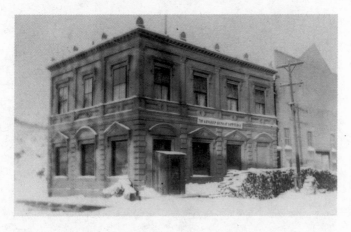

Clifford Thomspon worked at the Canadian Imperial Bank of Commerce in Dawson City. When Lillian arrived he reported the news to the Whitehorse Star. DAWSON CITY MUSEUM 1990.51.3

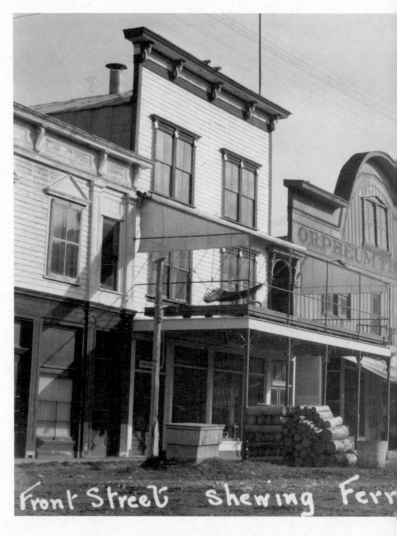

YUKON ARCHIVES, CLAUDE AND MARY TIDD FONDS, #8360

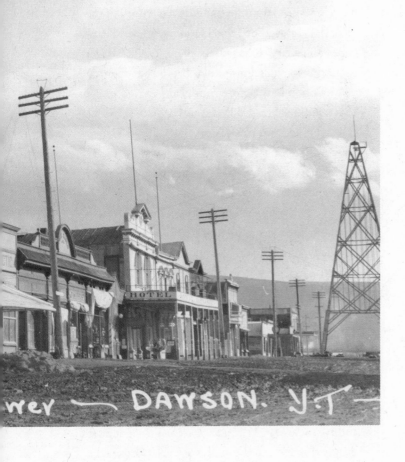

Dawson City

When Lillian Alling floated down to Dawson City, which lies at the junction of the Yukon and Klondike rivers, she was in the traditional territory of the Tr'ondëk Hwëch'in First Nations people, speakers of the Hän language. As the Klondike River is famous for its salmon, they had a settlement at that junction long before Europeans arrived in the 1890s looking for gold. The town the gold seekers established was named after Dr. George Mercer Dawson, explorer and scientist, who was the director of the Geological and Natural History Survey of Canada from 1895 until his death in 1901.

In 1898, at the height of the gold rush, Dawson City's population was about forty thousand, but the stampede for gold was soon over, and by the time the city was incorporated in 1902 most of the newcomers had left and the population had dropped to five thousand. By World War I, its economy had been weakened by the waning of the gold mining sector; it was further dampened by the loss of 125 residents in the sinking of the SS *Princess Sophia* in the Lynn Canal near Juneau, Alaska, in October 1918. That same year the US removed its consulate, and two years later the *Dawson Daily News* ceased daily publication and became a weekly. Businesses

gradually closed, people moved out of town or died and by the end of the 1920s, Dawson City seemed ready to die.[5] As a result, it was very much a bare-bones town that Lillian entered in the fall of 1928. Only the hardiest of northerners had remained for the oncoming winter.

Isobel Wylie Hutchison, who passed through Dawson a few years after Lillian was there, described it as:

> a quiet little town of a few hundred residents, with echoing wooden sidewalks (whose loose or missing planks are a trap for the unwary), closed premises, tumble-down buildings and deserted cabins. Enclosures where houses once stood are piled with untidy lumber—old iron bedsteads, barrels, broken pots and pans.[6]

Dawson City, Front St., c. 1922.
DAWSON CITY MUSEUM, 1984.236 1

by the same RCMP member that she was
to be detained in Dawson over the win-
ter as the ice was forming in the river and
it was not considered safe for her to travel
downstream.[7]

The police were well aware that travellers in the
north, especially lone hikers, could easily get into seri-
ous trouble if they were not warned of or prepared for
the harshness of the winters. In Lillian's case, the Dawson
detachment had likely been told she was on her way and
had already decided to detain her in town until the spring.

After she checked in with the police, said the *Daw-
son News*, "she stepped into the City Café on Second

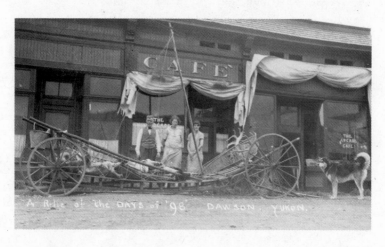

Dawson City, c. 1920s. YUKON ARCHIVES, CLAUDE AND MARY
TIDD FONDS, #8353

Avenue, owned by Adam Rystogi, where she enjoyed her first meal in the gold metropolis."[8] The *News* also recounted Lillian's method of travel, the distance she had covered, her overall condition, where she slept and what she ate. Even her clothes were a subject of great interest.

> Garbed in a pair of brown khaki over-alls, a badly torn black coat, with a man's heavy rubber boot strapped on one foot and a galosh on the other, the whole out-fit topped off with a faded brown hat, the quaint figure of the daring woman could not be mistaken.[9]

As Lillian was prohibited from travelling any farther, she needed a job to replenish her wardrobe and support herself until the spring melt came. Archie Gillespie told the *Yukon News* in July 1965 that one of Lillian's jobs that winter was at the Fournier Dairy and Roadhouse:

> As it happened she was able to get a job cooking at a dairy ranch some fifteen miles up the Klondike River from Dawson. The old-timer who ran the dairy, Archie Fournier, needed a cook for the winter, and when he heard of the plucky girl's predicament, he kindly offered her the job for the winter. Lillian Alling was very

happy to get the cooking job. She had done this kind of work before so the job posed no problem for her. By accepting this job for the winter she was assured of a warm home, plenty to eat and, besides, she would be able to save most of her wages for the fresh start on her journey the following summer.[10]

But Lillian's employment with Fournier seems to have been short-lived and only one of several jobs she held that fall. By December she was working at

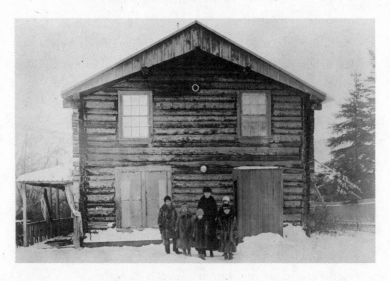

St. Paul's Hostel. YUKON ARCHIVES, ANGLICAN CHURCH, DIOCESE OF YUKON FONDS, 94/78, #3173D

St. Paul's Hostel

St. Paul's Hostel was a residence established by Anglican Diocesan Bishop Isaac O. Stringer in 1920 in order that children from the outlying areas could attend the combined elementary and secondary school that had been established in Dawson City in 1900. Most of the boarders at St. Paul's were the children of mixed parentage, the fathers usually white, so they were "non-status" and therefore not eligible to attend the residential schools in the area. The hostel received no government funding. Instead, support came from St. Paul's Anglican Church in Dawson City (established in 1897 to address the religious needs of the gold miners), missionary societies and local businesses (especially the Bank of Commerce). Parents who could afford to pay also contributed twenty-five dollars per month for each child. The hostel operated at first in a remodelled private home, but in 1923 it was moved to the former Samaritan's Hospital. Both the school and St. Paul's Hostel were closed June in 1952.

St. Paul's Hostel in some domestic capacity. A letter from Charles F. Johnson, the principal there, to Bishop Isaac O. Stringer early in 1929 gives one of the most detailed first-hand impressions of Lillian's personality on record.

> January 5th 1929
> My Dear Bishop,
>
> We have with us what is known as the "mystery woman." She is a Polish peasant woman who walked all the way from Telegraph Creek to Dawson, arriving here just as winter was setting in. She tried working in several places but people soon got rid of her as she is not much use. We took her in and gave her a home and thought that we might be able to straighten her up and polish the rough corners off her a bit but it is an uphill job. She is uncouth, proud and ignorant and of uncertain temper and there is very little she can do. However, she irons and sews after a fashion so that she earns her board. Every little bit that she does is a real help and relieves the others just that much.[11]

While Johnson's letter sheds light on Lillian's general temperament, it also demonstrates how difficult it was for this socially awkward, reclusive woman to spend her winter in Dawson cooped up with other people. Perhaps in some ways this captivity was as difficult as the

physical ordeals she had already suffered on her journey. She had been used to dropping into a settlement in the wilds for a few hours to eat and buy supplies. Here, she had to see the same people every day and form relationships with them.

Johnson's correspondence with the bishop indicates his constant worry over funding and staffing,[12] so while he probably kept Lillian on at St. Paul's Hostel for charitable reasons, it is also possible that a shortage of staff made employing her quite necessary. And although he pointed out the inadequacy of the work she performed, he still felt it merited payment. On March 25 he wrote to the bishop to say,

> We still have the so-called mystery woman with us, and while she is not much good, she does a certain amount and thereby relieves the others. Don't you think it would be only fair and just if I gave her a check for fifty dollars when she leaves here?

On April 17, less than a month later, Johnson reported that Lillian and St. Paul's Hostel had parted ways.

> We are all well here and the work is going on as much as usual. I had to get rid of the mystery woman. The girls got on her

nerves and she "ran amuck" amongst them,
so I had no choice in the matter. I am disap-
pointed in her, we had hoped to be of some
help to her but she would not respond to
anything we tried to do for her.[13]

Alex Van Bibber, who was living at St. Paul's Hostel
at that time, recalled that the children had made fun of
Lillian's accent.[14] Lawrence Millman, who wrote a story
for the *Yukon News* in December 2007, also tracked
down a ninety-five-year-old nun who had worked with
Lillian at St. Paul's. Sister Anne-Marie told Millman that
Lillian had stolen sugar from the pantry. The nun didn't
know why she wanted the sugar, but she did tell Mill-
man she thought Lillian was "a troubled soul."[15]

Ruth and Bill Albee, who travelled north two years
after Lillian and who had followed in her footsteps since
Telegraph Creek, found that the people in Dawson City
were still fascinated by Lillian, but once again the stories
they recounted held more fiction than fact:

We found people talking about a mysterious
Russian woman whose appearance among
them carrying a stuffed fox terrier under
her arm had caused much comment two
winters before. Were Red spies really after
her? Was that why she had tried to keep

out of sight, washing dishes all winter in a secluded mining camp?[16]

But former *Dawson News* reporter Archie Gillespie had good memories of Lillian. In 1965 he wrote:

> During that winter in Dawson she was able to pick up quite a bit of the English language and she made a number of friends who were astonished at her courage and determination.[17]

After a long winter, the breakup of the Yukon River is a magnificent sight. Everyone anticipates the sounds of ice pans cracking and the water flowing, and the whole town makes bets on the exact hour and minute that the breakup will occur. In her book *I Married the Klondike,* Laura Berton describes the scene:

> The sight of the ice moving was a spectacular one. The great cakes, three to eight feet thick, roared down the river, smashing and grinding against each other with the noise of a dozen express trains. Often entire cakes would be hurled into the air until the banks on both sides of the river were piled with them, sometimes to the

height of fifty feet. Occasionally, caribou could be seen clinging to the ice blocks as they swept by, or floundering in the water between them. Uprooted trees and the odd empty boat jammed into the ice would go sailing past the town.[18]

The spring breakup on the Yukon River must have been intimidating to Lillian as she planned the next leg of her journey.
YUKON ARCHIVES, CLAUDE AND MARY TIDD FONDS, #8327

In 1929 the ice broke up in the Yukon River in mid-May. Lillian wasted no more time in Dawson. She had put in her time there, she had survived being cooped up all winter, and she wanted to be on her way as soon as she could. She had no second thoughts about continuing her journey and no hesitation. Archie Gillespie describes her parting:

> After the river cleared and navigation got under way for another season, she was again on her way, still deeper into the north. Only, on this occasion she was much more warmly dressed and much better prepared.[19]

The *Dawson News* told of Lillian's departure in their issue dated May 21, 1929:

> The boat has been lying off the river bank all winter and this was her means of departure. She gave it out before departing that she was going to Nome and across to Siberia.[20]

She was alone again and on her way down the broad Yukon River toward Alaska.

Panorama of the Yukon River c.1920. DAWSON CITY MUSEUM
1984.76.1.7

Chapter Ten

Floating Down to Nome

I can only imagine the exhilaration Lillian must have felt at being once more on her way. She was now on the final leg of her North American journey with just 1,250 miles (2,000 kilometres) of the Yukon River between herself and the sea. But to reach that goal, she knew she first had to cross the border into Alaska without being observed by US Customs authorities because she had no papers to legitimize her presence in the United States. Given that she had been forbidden entry into the US at Hyder just a year earlier, she must have been quite nervous as she set off. And it seems pretty definite that she did not check in at the US Customs office at Eagle, Alaska, just west of the international boundary line: my inquiries to the US Department of Labor, which holds Customs records,

and with Ancestry revealed no record of anyone named Lillian Alling crossing at this point.

The river is wide here with a long island in the middle, and it would have been fairly easy for her to slip by, not stopping, perhaps under the cover of darkness, although darkness is scarce in that part of Alaska in mid-May. There are eighteen hours of full daylight followed by a long dusk and a couple of hours of night before the sky begins to lighten again. But, of course, her little skiff was not the only boat on the river, and that also

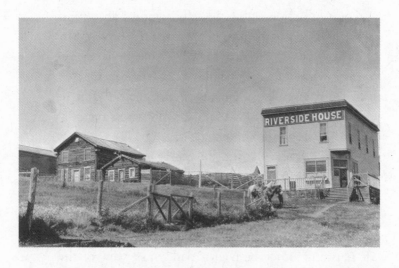

Eagle, Alaska, in the 1920s. ARCHIVES AND SPECIAL COLLECTIONS, CONSORTIUM LIBRARY, UNIVERSITY OF ALASKA ANCHORAGE. ALASKA CIRCLE TOUR PHOTOGRAPH ALBUM, 1927. UAA-HMC-0614

provided her with some cover. Breakup was the signal for hundreds of vessels of every size to be pushed down the river's banks and into the water. The largest of these were the sternwheelers, averaging 125 feet in length and about 30 feet in width (38 x 9 metres), and although their numbers had declined from a high of two hundred boats in the gold rush days, even during the 1920s and 1930s the British Yukon Navigation Company was still operating six to ten of them on the river during the busy sixteen-week open-water season.[1] These flat-bottomed, shallow-draft ships were ideal for work on the Yukon, which flows at a speed of eight miles per hour (13 km/h) after breakup and slows to about five miles per hour (8 km/h) later in the season. Whenever hailed, the sternwheelers stopped at the many settlements, hamlets and individual cabins dotting the shoreline, dwellings that reflected the stories of both Native life here and those whites who had stayed on after the gold rush and come to terms with the isolation of the north.

In her book *North to the Rime-Ringed Sun*, published in 1937, Isobel Wylie Hutchison, an amateur botanist from Scotland, described her own experience floating down from Dawson City and crossing the border in 1932.

> We slipped silently off downriver, past the hospital, past the Indian village of Moose-hide, through the pine-clad mountain

Eagle, Alaska

The first structure in Eagle, Alaska, was a trading post that was built beside the Yukon River in 1874, but by the end of the century the settlement had become the supply and trading centre for miners working the upper Yukon and its tributaries. By that time its population exceeded 1,700 people and it was incorporated as a city in 1901. The US Army also built a post here in 1900 but abandoned it eleven years later. A telegraph line between Eagle and Valdez, Alaska, was completed in 1903, and it was from Eagle's telegraph station that Roald Amundsen announced his successful transit of the Northwest Passage on December 5, 1905. By 1910, Eagle's population had declined to fewer than two hundred people and it has never exceeded that number since then. When Lillian passed by in mid-May 1929, Eagle consisted of a few stores, some log cabins, a church and a tall wireless mast.

gorges (the scenery beyond Dawson, where the river narrows between steep heights, is very fine) to our rendezvous at the bleak hour of 1 a.m. with the United States custom authorities at Eagle, fourteen miles beyond the international boundary. This boundary between the Yukon territory and Alaska, defined by William Ogilvie, first governor of the Yukon, and recently carefully redetermined, consists, at the point of intersection, of a broad belt cut through the timber which stretches over the hillsides to the far-off limit of the tree line.[2]

Lillian had left Dawson a few days before May 21. After a winter of little physical activity to keep up her muscle strength, she must have been relieved that there was no need to row her little craft, because at this time of year the river's flow would be carrying her downstream at a steady six or seven miles per hour (9–11 km/h). During these long days of early summer she could have stayed on the river until midnight if she wished, then gone ashore to sleep for a few hours and find something to eat, but this does not seem to have been the case. The American anthropologist Ales Hrdlicka, who was on a collecting expedition for the Smithsonian Institution

The Yanert Brothers

Among the cabins lining the Yukon River on the US side was that of the Yanert brothers—William, who had arrived in 1901 and built the cabin he called "Purgatory," and Herman, who joined him nine years later.[3] In the 1930 census Herman gave his occupation as trapper, but he had worked in the United States as a soldier and cartographer before coming to Alaska.[4] Both men had been trained as carvers in their native Poland, and their cabin, which was full of their carvings, was also flanked by two totem poles they had created. However, they were most noted for the large wooden sculptures with moveable parts that they installed along the riverbank. One was a devil with movable arms and a movable lower jaw, and whenever they spotted a boat coming down the river, they brought their devil to life using wires controlled from the cabin.

The American anthropologist Ales Hrdlicka, who met the Yanerts on June 20, 1929, described the working of this creation:

> When the boat arrives, one of the brothers from the house pulls the wires, the

> "devil" opens and closes its jaws, and works up and down the hand with the pitchfork. All of which, with the real gruesomeness of the figure, must produce quite an impression. All this the fruit of lonesomeness of two solitary intelligent people, and of all the "hell" they have endured.[5]

in the summer of 1929, often heard of a "lone white woman" travelling just a few days ahead of him. He also reported that she "stops at cabins for sleep and food."[6] Apparently, she was going downriver no faster than he was, and his job was to spend the entire summer stopping at points along the river to investigate the country and the people. Author Colin Angus, using a craft similar to the one Lillian used, with no mechanical propulsion whatsoever, was able to travel over 900 miles (1,500 kilometres) down the river from Dawson—that is, almost three-quarters of the distance to Nome—in just ten days.[7] It becomes obvious that Lillian, for reasons of her own, was travelling at a casual speed, often stopping for long periods of time to camp and rest onshore.

Hrdlicka's job on his Smithsonian expedition was mainly to take photos, make notes and collect artifacts. Fortunately, he also kept a diary in which he recorded

the weather, the travelling conditions and the people he met. In late June he reported:

> Since the middle of the month there are no more any real nights. The sun—when the sky is clear enough—shines to near midnight, or there is at least the reflection of its light, and then follows only a moderate dusk, which soon begins to grow slowly into another daylight. Late on such evenings, when the air is peaceful, slight mists rise from the water, the dark banks and islands mirror in the glazed expanses of the stream, and the whole nature seems dozing—just a light doze, no real sleep.[8]

Hrdlicka's diary entry for July 3 notes that the white woman who was travelling ahead of him was using

> [A] boat with a queer wheel contraption … but is secretive. Says she is bound for Siberia. Is Polish or Russian. "Broke" into Williams' house and stayed there overnight but did not take anything. Everybody speculates about her strange proceedings, but those who spoke to her say she is not insane. "Writes novels," or "perhaps a criminal."[9]

From Hrdlicka's description, her boat appears to have acquired some kind of mechanism that it did not have when she arrived in Dawson the previous fall, but perhaps someone had showed her how to set up one of her oars as a rudder, allowing her to face forward while she steered. A more curious aspect of his diary entry is the fact that the Williams he mentions lived six miles from Galena, which is situated at the "Merry Widow Bend" of the river. This means that, by early July when she had already been on the river for about forty-five days, Lillian had only travelled about 845 miles (1,360 kilometres), or just two-thirds of the way from Dawson City to the sea. With this information I began asking myself why she was not taking full advantage of the short summer to reach Nome as quickly as possible. Had she changed her mind about going to Siberia? Was she unwell? Or had the terrors of her trip by raft and skiff from the Stewart River to Dawson City the previous fall left her with such a fear of the river that she only embarked for short distances before tying up for days at a time?

After the Alaskan settlement of Mountain Village, the Yukon River splits into many channels, sprawling into the marshy land across the wide delta. The water here remains fresh due to the high volume pouring down the river, and the delta gets no swells from the

ocean because the Bering Sea remains shallow as far as 10 miles (16 kilometres) out, and this prevents any of the really large waves from reaching the shore.[10] However, the rise and fall of the tide can cause serious problems for someone not used to tides, and that is apparently what happened to Lillian.

The *Nome Nugget*, catching up with her adventures in late August, reported to its readers that she had lost her boat and been forced to find another way to continue on to Nome.

> ...upon arriving at the mouth of the mighty Yukon, the lady pulled the nose of her boat up on the beach while she prepared herself something to eat. In the meantime the tide came in and the boat floated out to sea and was never seen again. This caused the lady to walk back to Kotlik where she arranged to come to Nome on Ira Rank's boat. It appears that she is headed for Siberia via Cape Prince of Wales.[11]

The newspaper does not explain how far Lillian walked from the point where she lost her boat to the village of Kotlik or how long she waited there for transportation to Nome, but from her rate of travel earlier in

the summer it is likely that she had arrived at the river's mouth by the end of July. Kotlik lies on the east bank of the Kotlik Slough at the mouth of the Yukon, but because the channel on which it is situated is somewhat deeper and wider than the neighbouring channels, historically it has provided easy access for large riverboats and barges. As a result, it became one of the primary commercial and trading centres of the lower river. One of the traders who called in at this port was Ira Mahon Rank, a well-respected merchant—originally from Ohio—who also operated a ship named the *Trader* with which he transported goods and passengers from place

Ira Rank's boat, the Trader. CARRIE M. MCLAIN MEMORIAL MUSEUM, NOME, ALASKA

to place along the shores of the Bering Strait.[12] Rank did not actually take Lillian to Nome as that city's harbour could not accommodate boats as large as the *Trader.* Instead he took her to St. Michael, a small island near Nome, which was used to dock the larger boats.

Even before Lillian arrived in Nome, she was expected there and people were curious about her, and on August 31 the *Nome Nugget* reported that she had finally made it to town.

Nome, 1920s. CARRIE M. MCLAIN MEMORIAL MUSEUM, JACOBS, 22, NOME, ALASKA

Nome, Alaska

Nome, situated on Norton Sound on the shores of the Bering Sea, was established after gold was discovered on nearby Anvil Creek in 1898. Within a year 10,000 prospectors and miners were living in a tent city along this treeless coastline. The city itself was founded in 1901, but the origin of its name is unclear. One story says that the hydrographic office of Britain's Royal Navy couldn't find a name for the nearby cape and the cartographer wrote the word "Name?" on the map. Later an engraver mistook that for "Nome."[13] The name may also have been given by the town's founder, Jafet Lindeberg, in honour of the Nome Valley in his native Norway.

Although placer gold mining has remained the leading economic activity in this area, by 1910 the population of the town had shrunk to 2,600 people. It suffered a destructive fire in 1905 and ruinous storms in 1900 and 1913, but botanist Isobel Wylie Hutchison, who visited the city in 1932, explained its subsequent state of disrepair:

> The glacial subsoil causes much shifting of
> the frame buildings which constitute most

of the "city," giving to present-day Nome its somewhat dilapidated appearance. Most of the houses are built of wood, and the street and sidewalks are planked.[14]

The only access to Nome in the 1920s and 1930s was, as now, by boat or plane.

The "mystery woman" from Dawson arrived at Nome on the motorship *Trader*. It will be recalled by Nugget readers that we printed an article a few weeks ago that the lady was marooned in Dawson last winter and planned to come downriver to Nome this summer. It was learned that she obtained a small row boat and started out from Dawson.[15]

This short newspaper article is the last documentation of Lillian's time in Nome that I was able to find. This did not surprise me as she was in Alaska illegally, and although she had taken an inordinate amount of time to travel the Yukon River and make her way to Nome, she must have been in a rush now to leave before sea ice would make a boat trip across the Bering Strait impossible. It was already the beginning of September and daytime temperatures at this latitude drop below

freezing by mid-October, remaining there until mid-April. The Smithsonian anthropologist Ales Hrdlicka, observing the people along the river making preparations for freeze-up, wrote in his diary:

> The summer season on the Yukon [River] is nearing its end. This means that soon there will be frosts, that transportation, what little there is of it, will be on "its last legs," and that everybody who can will now endeavour to get out, which is not always easy or even possible.[16]

Once the ice began to form, all maritime traffic would cease.

Cape Prince of Wales, Alaska. The forbidding coast that lay between Lillian and Siberia. UNIVERSITY OF ALASKA, FAIRBANKS UAF 1959-875-1, PHOTO BY S.S. BERNARDI

Chapter Eleven
The Final Walk

After leaving Nome at the beginning of September 1929, Lillian began walking toward the small Alaskan village of Cape Prince of Wales, the westernmost point on the Seward Peninsula, where she apparently planned to hire someone to take her the 52 miles (84 kilometres) across the Bering Strait to Siberia. Unfortunately, I could find no further coverage of her journey in the Alaska newspapers once she left the Nome area—no travel progress reports, no death notice, no obituary—perhaps because no one passed along news of further sightings. And within a very short time other news had become more important, including the instability leading up to the Wall Street stock market crash of October 1929 and, closer to home, the attempt to rescue the ship *Nanuk* and the subsequent loss of one of Alaska's premier pilots

and his mechanic, which made local, national and international news that fall and winter.

What happened to Lillian Alling after she set out to walk to the Cape from Nome, Alaska, has been the source of much speculation. But I discovered that there are just two possibilities: either she drowned in Alaskan waters or she made it safely across the Bering Strait to Siberia.

Isobel Wylie Hutchison arrived in Nome in 1932, three years after Lillian was there, and hired Ira Rank, who had transported Lillian to Nome on the *Trader*, to take her on a botanical expedition. There were strong winds on their first night out of Nome, and Rank tied up the *Trader* in a bay behind Cape Prince of Wales where two miners, Arthur McLain and George Waldhelm, were operating "America's only tin mine." The miners were happy to share their food and entertain their guests with stories of the north.[1] One of Waldhelm's tales was about a woman who was walking alone with the intention of travelling across the strait to Siberia. Though the miners incorrectly identified her nationality as Dutch and thought she had been working in Fairbanks as a waitress, it is likely that the woman they discussed was Lillian Alling. Hutchison transcribed their conversation as she remembered it in her memoir, *North to the Rime-Ringed Sun,* published in 1937:

Waldhelm: "Then there was the little Dutchwoman, too—they found some of her clothes on the hillside and a letter addressed to someone in Holland, I believe. It was said that the natives got it, but I think it was lost."

Ira Rank: "We met her down the Yukon. It was the *Trader* that brought her as far as St. Michael."

Isobel: "What was she doing?"

Waldhelm: "She was on foot, walking round the country—a regular rag-bag her clothes were by the time she got to Cape Prince of Wales. They had warned her not to go in winter, but she wanted to walk right up the coast—they said she was working as a waitress at Fairbanks, but her home was in Holland."

Isobel: "And did they ever find her?"

Waldhelm: "No, I don't think anyone quite knew what became of her—I forget—they looked for her body, but they only got the clothes and the letter."

Isobel: "And was the letter never delivered?"

Waldhelm: "No, I think the native lost it, I can't remember. It's a hard country, especially for a woman. She ought never to have tried it all alone, but I guess she was a bit queer, too."[2]

Ruth and Bill Albee heard a similar but more far-fetched story of Lillian dying in Alaska when they were teaching school in Cape Prince of Wales in 1934. There they met Charles Levan, a wireless operator for the government[3] who also had the job of delivering mail. One day when Levan dropped by to visit the Albees, he told a tale about Lillian:

Levan: "Ever here [*sic*] speak of a Russian woman with a dog?"

Albee: "A stuffed dog? Why she went up the trail just a year ahead of us."

Levan: "Well, I'll be damned! Say, what d'y' know about that?"

Albee: "You saw her in Nome?"

Levan: "Sure did. We all did. Her and her little stuffed dog. You'd have thought

'twas alive, the care she gave that thing. Plenty of talk about her, too. Bound for the Strait, they said, with a crazy notion of somehow getting across to Siberia. Anyhow, last we saw of her she was heading this way across the beach, hauling that stuffed critter in a little cart behind."

Albee: "What do you suppose ever became of her?"

Levan: "Drowned, most likely. An Eskimo found her tracks later at the mouth of a flooded river between Nome and Teller."

Bill Albee: "In the silence, he [Levan] settled back, puffing contentedly. Ruth and I could almost see that strange, fascinating Russian still tramping resolutely north with her stuffed dog, so vivid had she become through repeated hearsay. What irony to have lost out finally when almost in sight of her goal! She seemed too real, too alive to have died that way. Could it be that she hadn't drowned, after all? Strange things happened in the North. Perhaps some oomiak [a Native skin boat]

had just come along and picked her up at the mouth of the river ... If so, might she not have reached Siberia in the end? How we should like to know! The chances are we never shall."[4]

The author most firmly planted in the camp of those who believed Lillian had drowned in Alaskan waters was J. Irving Reed, who wrote an article in 1942 entitled "Did She Reach Siberia?" In this article, published in *Alaska Life* magazine, he claims to have met Lillian in 1929 as she was pulling a cart along the highway just outside of Nome. He told her that she was on the wrong road for the Seward Peninsula and offered her a ride. He tied her cart to the back of his car and put her two bundles, which weighed altogether about forty pounds (eighteen kilograms), on the seat beside her. Then, noticing that her cart's wheel was broken, Reed drove to a machine shop to get the wheel fixed. While they waited for the repairs, they sat in the car and chatted. Reed said, "I believe in our one-hour conversation there outside the machine shop, she told me more than she had anyone else at Nome. She gave

"... she might not have reached Siberia in the end. How we should like to know! The chances are we never shall."

her name as Mrs. Lillian Alling."[5] Once Lillian's cart was fixed, Reed wrote, Lillian continued on her way.

He concluded his article by stating that he made many inquiries and they all led him to believe that Lillian never made it to Prince of Wales Cape. He stated that her cart was found abandoned at the Sinuk River, 20 miles (32 kilometres) north of Nome. Furthermore, he explained:

> Last summer I was told that her clothes and supplies were found by Eskimos at the so-called "mouth" of the Tisuk River, fifty miles further along the coast. This is a narrow estuary opening into the Bering Sea and blocking her way. Though this strip of water is narrow, it is very swift and deep. It is the outlet of a large lagoon into which empty the Tisuk and two or three other rivers. Facing her on the western shore of this estuary was an old, abandoned roadhouse. Evidently Lillian Alling stripped to her underclothes and attempted to swim across. She probably hoped to find a boat at the old roadhouse and to return in it for her clothes and supplies. Undoubtedly she was caught in the swift current and carried out to sea.

> She took a chance, as many other trav-
> elers had done before her, and lost. It is
> rumored that in Gold Rush days others
> were drowned at this same place.[6]

Although the author of this article was listed as J. Irving Reed, he was probably Irving McKenny Reed since his credits state he was a mining engineer and that was also the occupation of lifelong Alaska resident Irving McKenny Reed. In addition, the photo of J. Irving Reed that accompanies the article matches in appearance and stance a photo of Irving McKenny Reed (1889–1968), who married Eleanor Doris Stoy, a prolific writer and artist, in 1923. They made their home in Fairbanks, Alaska, for the remainder of their lives.[9]

I had a number of doubts about Reed's *Alaska Life* article. First, in October 1929 Eleanor Reed had interviewed Winfield Woolf, a young adventurer who had hiked the same route from Hazelton to Dawson that Lillian Alling had travelled but who had arrived in Dawson a year later than she did. Then, although the RCMP attempted to detain him there for the winter of 1929–30, he had walked from Dawson to Fairbanks, suffering a severe case of frostbitten feet, and he was in the Fairbanks hospital recovering when Eleanor interviewed him. This interview became the basis for her story "I Walked Empty Handed," which I found

The Rescue of the *Nanuk*

In the fall of 1929, Alaskan trader Olaf Swenson piloted his ship, the *Nanuk,* to his other ship, the *Elisif,* which had been icebound in the Arctic for several months. On the way back the *Nanuk* also got jammed in the ice off North Cape. As Swenson had his family on board plus a large quantity of valuable furs, he radioed for assistance, and it was arranged that the noted explorer and Arctic flyer Carl Ben Eielson would rescue the crew members and fly out the furs. The first round trip to the *Nanuk* and back to Alaska was successful. On the second flight on November 9, 1929, Eielson and his mechanic, Frank Borland, flew into a bad storm over the Siberian coast and disappeared. Local villagers heard the plane crash but did not see it.[7]

Diplomatic relations were tense between the United States and the Soviet Union in 1929, but when the Americans asked the Soviets for help locating the downed pilots, the Soviets sent out dog teams and launched planes from Kamchatka.[8] The plane was not found until January 24, 1930. A faulty altimeter was probably a contributing factor to the accident as the plane had crashed into the ground with its throttle wide open.

in the Reed Family Papers at the University of Alaska
Fairbanks. It is apparent from it that Eleanor Reed did
not discuss Lillian's journey with Woolf. Perhaps she was
unaware of it at the time of the interview, even though
Lillian had arrived in Nome just two months earlier, but

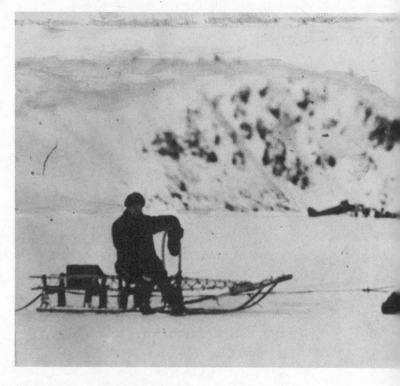

The Swenson Fur Trading Company's motorship Nanuk *frozen in
the ice near North Cape, Siberia, in the winter of 1929.*
ASSOCIATED PRESS

it is strange that her husband could have had his interesting chat with Lillian on the road outside Nome without telling Eleanor about the encounter.

Second, also in the Reed Family Papers is a copy of a letter Eleanor wrote in March 1939 to the RCMP in

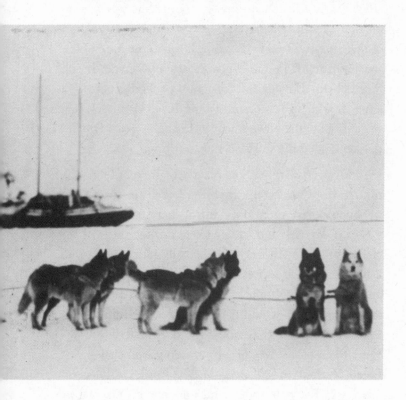

Dawson seeking information on the early part of Lillian's journey—information that had been freely available in newspapers across the north while Lillian was en route. In addition, the Reed Family collection includes a letter dated April 23, 1939, from Eleanor to the editor of the *Alaska Sportsman* concerning a story that she was writing for them about Lillian Alling, as well as an undated draft of that story written by Eleanor. It forms the basis of the article that ended up in *Alaska Life* in 1942 under Irving Reed's byline. Finally, the collection contains a copy of a letter in which Eleanor and Irving Reed are attempting to get hold of the November 1941 issue of *True Magazine* that contained the story on Lillian Alling.

However, if Irving Reed had actually met Lillian on the road outside Nome in 1929, I feel sure that Eleanor would have mentioned this in her correspondence with the RCMP and in her letter to the editor of the *Alaska Sportman*. In fact, if he actually sat chatting with Lillian in his car as he stated in his *Alaska Life* article and she really told him "more than she had anyone else at Nome," there would have been no need for all this research and the Reeds would not have waited fourteen years to publish the story. I am convinced that Irving Reed learned of Lillian's journey from local legend, articles in BC newspapers and information taken from the books written by Isobel Hutchinson and the Albees

as well as the 1941 *True Magazine* article, and he then embellished it with elements from Woolf's story and a great deal of fiction.

Three Alaskan tales, all second-hand or based on hearsay, all telling of Lillian possibly drowning just before she could cross the strait. But did she really succumb to the elements, so close to the end of her journey? She faced obstacles with determination and resilience, and I believe she reached Siberia against the odds.

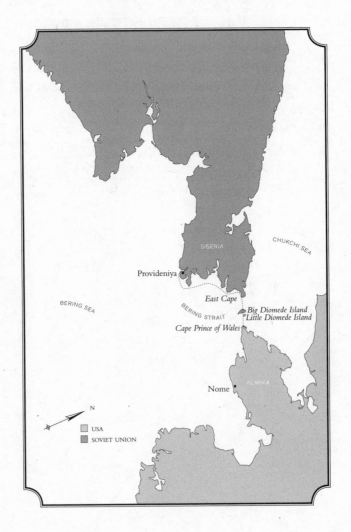

Chapter Twelve

Prince of Wales to Siberia

The village of Prince of Wales, more generally known as just Wales, is located on the tip of the Seward Peninsula, 111 miles (178 kilometres) northwest of Nome. It has been the home of Inupiat Eskimos for thousands of years, and until the influenza epidemic of 1918–19 killed a large proportion of the population, it had been a major centre for whaling due to its strategic location on the animals' migratory route. By 1929, the economy was based mainly on subsistence hunting, fishing and trapping. Ales Hrdlicka, the Smithsonian anthropologist, visited the small settlement of Wales a few years after Lillian's journey. His diary notes,

> Wales is a straggly village, or rather two
> villages, located on a large, flat, sandy spit,
> dotted with water pools and projecting

from the Seward Peninsula toward Asia …
From the hills above it, the natives assure,
one can see on a clear day the East Cape
of Asia.[1]

The Seward Peninsula was once part of the Bering
land bridge, a thousand-mile-wide swath of land that
connected Siberia with mainland Alaska during the last
ice age, which ended about 11,700 years ago. It provided

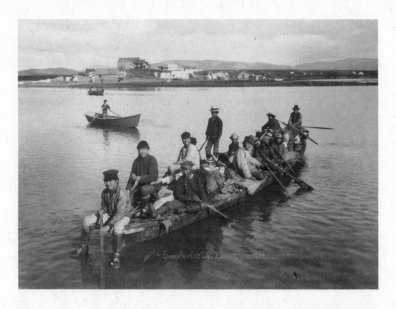

Natives from East Cape (Siberia) visiting Snake River, Nome, Alaska, c. 1910. CREATOR B.B. DOBBS, CREDIT ALASKA STATE LIBRARY ASL–P12–138

an entryway for plants, animals and humans to migrate from Asia to North America. After the ice melted and the waters rose again, the bridge disappeared beneath a shallow sea that was just 52 miles (84 kilometres) wide at its narrowest point between the continents. Cape Prince of Wales on the Seward Peninsula is the closest point on the Alaskan mainland to the mainland of Russia. Opposite it sits Cape Dezhnev or East Cape in the Soviet province of Chukotka. The Chukchi people who live there have traditionally made their living by fishing and hunting, and they traded with people from other regions in the Soviet Union and with the American mariners and traders who plied their trade in the Bering Strait.

In spite of strained relations between the US and the Soviet Union in 1929, the Native people of both countries still travelled regularly across the strait each year from June through November—when the water is usually ice-free—in order to trade and buy supplies. This traffic was either ignored or undetected by authorities on either side of the strait. In winter, groups from each side of the Bering Strait would would travel by dogsled, meeting off the Diomede Islands, which lie between the two countries, and camping on the ice. Little Diomede Island belongs to the US, while Big Diomede is part of the Soviet Union; the international dateline runs between them.

The boats used by the Native people on both sides of the strait were called umiaqs (or oomiaqs or umi-aks), walrus-hide boats that were specifically constructed to handle the waters of the Bering Sea. Ruth and Bill Albee, who taught in Wales, Alaska, in 1934, gave a good description of the local boats in an article they wrote for *Practical Mechanics* in 1938:

> In developing the oomiak, these Eskimos faced the problem of designing a boat for hunting walrus and whales in the stormy waters of Bering Strait with its crushing ice floes and treacherous currents. Since whales often weigh as much as fifty tons and walrus from 2,000 to 3,000 pounds each, they must be hunted by large crews. The boat must be capable of transporting eight to ten men, surviving heavy weather and bringing home the catch.
>
> The oomiak is dory-shaped for sea-worthiness, and from twenty-five to forty feet long. The frame is of light driftwood spruce, each piece carved to shape and the pieces lashed together with rawhide thongs ... Each oomiak is equipped with oars, paddles, mast and sail, and usually

an outboard motor. The oars are used for long pulls, should the motor fail; the paddles for fast work amid ice floes; the sail to take advantage of favorable winds. Caught far out at sea, with a whale in tow, the crew may utilize motor, sail and oars simultaneously. We found no record of any oomiak crew at Cape Prince of Wales having been lost at sea.[2]

In his book *Arctic Trader*, published in 1957, the well-known Alaska trader Charlie Madsen explained how Native people on both sides of the strait were happy to purchase motors from him:

> When improved models replaced the earlier motors, I was able to barter quite a few outboards to natives along the Arctic Coast, at the Diomedes and King Islands, and Cape Prince of Wales. It became the custom for a number of Eskimos of King Island, the Diomedes and Cape Prince of Wales to unload their families, dogs, cooking utensils and food into umiaks equipped with outboards and sail to Nome for the summer, where they set up shelters outside the town ... [These motors] were

accepted with wholehearted enthusiasm
by Chukchis and Eskimos not only for
long journeys but likewise in their hunts
for seals, sea lions and whales.[3]

However, it was not just the Native people who
crossed back and forth between the two continents.
Many Alaskan merchant ship owners, such as Charlie
Madsen and Olaf Swenson with his ships, the *Nanuk*
and the *Elisif*, were also regular visitors to the Siberian
side to trade western goods for furs with the Chukchi
people. As well, some of the North Americans who
traded in Siberia moved there and lived with Chuk-
chi women, thereby cementing relationships with the
Russian people. Thus, although the Albees' postman had
dubbed Lillian's plan to seek passage across the strait "a
crazy notion," it was not crazy at all. It was, in fact, quite
reasonable for her to expect to travel to Siberia with
Chukchi traders who were returning home from a trip to
Alaska, or with Inupiat people from Alaska as they trav-
elled to the Soviet Union. Alternatively, she could have
hitched a ride with an American trader on a regular trip
to the Diomedes and gone from there with Chukchi
people to East Cape in Siberia.

The term Siberia is neither a political delineation
nor an economic one. It is geographic and cultural, and
usually means the area of the Soviet Union east of the

Ural Mountains, continuing all the way to the Pacific Ocean and Bering Sea. It has diverse climates, cultures, peoples, languages, economies and ecologies. The remote Siberian villages in the Soviet province of Chukotka where Lillian would have landed relied on hunting, fishing and trading to survive. During poor fishing or hunting years, it was human against nature, and nature inevitably won. As a result, in the 1920s, the Soviet government set up a series of trading posts, which assisted with supplying both food and community connections and also provided control over the lives of the people in this area.

The Chukotka population was not literate in the late 1920s because the Chukchi did not have a written language; this did not begin to change until 1931 when the Soviet government implemented education in both Russian and Chukchi. As a result, in 1929 there were no newspapers in Chukotka,[4] although one paper from neighbouring Kamchatka, *Poliarnaia zvezda* (North Star), an organ of the Kamchatka District Bureau of the Communist Party, District Executive Committee and District Professional Union, was distributed there. However, my checks on its contents revealed nothing about Lillian or news of any foreigner landing on Siberian shores between September and December 1929.[5] I have also been unable to find any oral accounts as the

The Journey of John William Adkins

In 1926, three years before Lillian made her journey across the Bering Strait, young John William Adkins from Maine had been working in Alaska when he decided he would try to obtain work in the Soviet Union. On July 27, in Nome, he hired Ira M. Rank's *Trader* to take him to Little Diomede Island. There he hired some Native people to take him in their skin boat to East Cape on August 1.

Adkins reported to the GPU (the State Political Administration, which later became the KGB) as soon as he landed. He had no passport and no visa, but he stated he was looking for work, and if he could not find work, then he wanted to take a Russian ship to Japan or Argentina. He received permission from officials to board the Russian ship *Astrakahn,* but when it stopped at Petropavlovsk he was arrested as an illegal immigrant by the GPU there, who were less accommodating than their East Cape counterparts. Adkins was jailed for two months, but he was then given permission to live and work in the USSR. Unfortunately, after working for a few years he fell victim to the Soviet terror and died in a prison camp.[6]

region was sparsely populated, and the population later dispersed due to starvation. I could also find no official documents referring to her nor any other trace of her in Russian archives. In fact, I discovered that it is extremely difficult to get any information about the history of the Siberian coast in 1929.

I asked myself what could have happened to Lillian once she landed on Siberian soil. I believe the main problem she would have confronted, once in the Soviet Union, was the burgeoning bureaucracy of terror. It is possible that, like John William Adkins, she was immediately

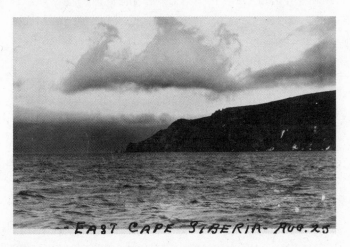

East Cape, Siberia. ALASKA STATE LIBRARY, US REVENUE CUTTER SERVICE PHOTOGRAPH COLLECTION, P79-107

required to sign in with Soviet officials, and if, like him, she met with a friendly face, she may have been allowed to continue down the coast of Siberia. Alternatively, she may have come up against the full force of Soviet officialdom and been thrown immediately into jail. She appears to have had no passport that would allow her to legally enter the Soviet Union. Even if she held one issued by the pre-revolution Russian government, it would not have been valid under the new regime. In fact, it is not known whether she held a passport of any kind. Certainly she did not hold an American passport or she would not have been turned away at Hyder, Alaska. There is no record of her presenting any documents to the Canadian Customs officer at Niagara Falls, and in the three years she travelled across North America, she does not seem to have had any other identifying documents in her possession. (T.E.E. (Ern) Greenfield says that, when Lillian was arrested in BC, she carried a landing card showing that she had arrived in New York in 1927, but since she was already on her way across Canada by that date and he was recalling events some forty-five years after they happened, there is no proof that she carried this document. In addition, he is the only person to have mentioned it.)

Perhaps, though, she managed to arrive onshore unnoticed by anyone except local residents. Then the

most likely scenario is that she remained in Chukotka for the winter because, if she set out alone and on foot across the treeless tundra at that time of year, she would not have access to her usual diet of berries and leaves and she would never have survived the desperately cold temperatures. It is possible, however, that she travelled farther inland by dogsled or reindeer team with Chukchi hunters. In the fall of 1928, Olaf Swenson, the Alaskan owner of the *Nanuk* and the *Elisif,* made an overland journey to the city of Irkutsk, hiring relays of dog and reindeer teams. The trip covered 4,300 miles (6,920 kilometres) and took 113 days—they often travelled day and night—but Swenson had the money to finance such a trip. As far as it is known, Lillian's funds were extremely limited. Perhaps, however, she could have afforded passage on a boat that would have taken her farther down the coast to a larger town before she headed west, although south of the tundra she would have met the impenetrable swampy coniferous forest of the subarctic known as the taiga. In his book *In Bolshevik Siberia: The Land of Ice and Exile,* explorer Malcolm Burr described the Siberian taiga as Lillian would have seen it in 1929:

> And so we entered the taiga . . . the huge,
> dense, impassable jungle where the trees
> struggle with each other to reach the light
> and upper air, where giants die and crash

down to lay rotting on the ground and make soil for the next generation. It is a strange world. Only three roads cut it, the great rivers Yenisei and Lena, which run away to waste in the Arctic, and this great long ribbon of a railway which has cut its path through it from west to east. The rest is roadless, a mass of bog and rock covered by shrub and the endless forest with here and there an oasis cut by some enterprising settler in the neighbourhood of the [rail] line or along the trees.[7]

It seems to me that where Lillian was headed after she landed in Chukotka would have depended on who she really was and what her final destination was. If she was a Polish national and was trying to return to Poland, her best course of action would have been to head all the way south to the port city of Vladivostok, which was, and is, the terminus for the Trans-Siberian Railway. From there she could have taken the train all the way to Poland. The main difficulty with that choice was that she would been checked regularly by customs and passport control. But if, lacking papers and money, she could not actually ride the train, she could have chosen to walk the 4,500 miles (7,240 kilometres) through Russia to

Poland following the rail line. This would have allowed her to avoid passport control and other government representatives altogether.

If she was attempting to rejoin family members exiled to Siberia, it is uncertain what her destination would have been. Polish people had been exiled to Siberia for nearly a century and were scattered throughout the entire region. She may have had a difficult time locating them, although it is possible that she had received specific instructions before leaving New York State.

However, she could not have picked a worse time to enter the Soviet Union. By this time millions people were dying in the Soviet gulags of Siberia. Some starved to death, were shot or were beaten to death. Some simply died of overwork or exposure.

In spite of all the strikes against her, I still believe there is a strong possibility that Lillian Alling not only made it safely to Siberia but also reached her ultimate destination. Part of that belief comes from a letter written to the editor of *True West* magazine. After Canadian author Francis Dickie (1890–1976) wrote an article entitled "New York—Siberia: The Astonishing Hike of Lillian Alling," which was published in the April 1972 issue of the magazine, one of his readers, a man named Arthur F. Elmore of Lincoln, California, responded with

a letter to the editor. It seems that a few years earlier, Elmore had been told about a woman who could have been Lillian arriving on the Siberian shore. He wrote,

> After reading the article I decided to write because of a very peculiar incident that occurred back in 1965 when I was a visitor to Yakutsk, Eastern Siberia. I had been invited by a Russian ex-Army man, with whom I had become quite good friends in Mukden, Manchuria, during the closing days of World War II, to come and visit if I ever got the chance. The opportunity finally came in April 1965 when the Cold War had thawed, so I went to San Francisco where I secured passage to Moscow. In Moscow I then flew to Yakutsk where I located my friend.
>
> It seems he, like I, enjoys mysteries, and one day while exploring around (as much as one was permitted to do), he suddenly asked what I considered a very strange question. "If I were in America, how would I be treated?"
>
> Somewhat taken aback, I replied "In what way do you mean? What makes you

ask that?" Then he told me the following incident.

As a young boy—somewhere around fourteen or fifteen—he had lived in a very small community in the Soviet far east named Provideniya [on the southern tip of the Chukotka peninsula], which is about 170 or 180 miles from the present town of Wales, Alaska, across the Bering Strait. He stated that one afternoon while on an errand for his mother he saw a crowd gathered on the waterfront and several official-looking men were present, questioning a woman and three Eskimo men. He said he recognized that the Eskimos were from the Diomede Islands in the Strait by their dress, but the woman was differently dressed, like a European or an American.

He remembered the woman telling the officials she had come from America where she said she had been unable to make a living or make friends (of necessity I'm condensing much of what I was told to save space). She said she had had to

walk "a terrible long way because no one would lift as much as a finger to help me in any way because they didn't want to—or couldn't understand—my feelings. I tried to make friends at first, but everyone wanted no part of me—as a foreigner—and that so deeply hurt me I couldn't bear it and so I began to walk. I knew it was far and it would be hard but I had to do it even if no one understood. And I did it!"

He told me he saw the girl and the Eskimos led away—he never saw them again—but the memory was to linger with him always. He also stated this took place in the fall of 1930—he was very positive of the date because he stated his parents and his family were moved two years later farther westward to a place named Ust Yansk where his father fished commercially.

For several years all of this sort of haunted me—all mysteries do, in one way or another—but I never could figure out any answer. Then this past week I happened to pick up your magazine and saw the article.

Now I'm really curious! Is it possible that the girl with the three Eskimos could have been Lillian Alling? The Eskimos were definitely dressed as the Eskimos of the Little and Big Diomede Islands do. The only thing is—no black and white dog was visible or I'm very certain my friend would have said so. Anyway, knowing the people and the country as well as I do—I've spent nearly two-thirds of my life in Alaska—I'm very, very sure Lillian made it! Though, of course, I have no proof.[8]

According to the US Veterans Gravesites listings, a man by the name of Arthur F. Elmore (June 17, 1924–November 14, 1985) did indeed serve in the US Army in World War II, beginning February 12, 1943. And as stated in his letter, Elmore may have been in Manchuria at the end of the Second World War serving with the 1.5 million Soviet men stationed in the region at that time. Could Elmore be right about Lillian's fate?

If Lillian reached Siberia, she would still have had to face the political upheaval of the Soviet Union, not to mention the barren terrain. But if any traveller could weather these conditions, it was Lillian.

Epilogue

illian Alling's story begins and ends with a mystery. Where did she come from and why did she want to return there? This book is an attempt to find the answers to those questions through a careful investigation and analysis of every word I could source that has been written about her in the last eighty-four years.

What I learned was that she was an extraordinary woman who achieved an extraordinary feat. She walked alone across thousands of miles for more than three years. Today people sail around the world or walk great distances or climb high mountains, but they are accompanied by radios, sponsors, money, the support of family and friends, emergency beacons, communications equipment and safety supplies. So although they may be responsible for the actual accomplishment, it is by no

means a solo event. From the time Lillian crossed the border from New York into Ontario to the time she left Alaska to cross the Bering Strait, she had no transportation, guide, companion or any entourage at all. She had no contract to write a travelogue or a series of newspaper articles. And as far as we know, she didn't write home—wherever home was for her.

To survive in the extreme circumstances in which she found herself requires certain personality traits. The editor of the *Dawson News* wrote admiringly:

> Lillian Alling is so small and trim of stature that one is forced to wonder how a woman of such frail build could ever prove the conqueror of an overland course which leads through the tangled nooks and corners of a vast Northern wilderness. She has proved herself a human dynamo, a dominant driving mistress of her own destiny, a resolute woman with a will that has proved a way. [1]

But her unique characteristics were more than just this. She was a loner, thriving on solitude in the wilderness for extensive periods. But over the course of her journey she went from being so afraid of people she carried an iron bar for protection to trusting hundreds

of strangers as she trekked through British Columbia, the Yukon and Alaska. Because she learned to trust people, she survived through their help and her own strong character.

She was decisive, singled-minded, focussed and, some would say, obsessed. Of course, there's a fine line between being admired for one's stubbornness and being thought crazy. Lillian never wavered in her determination to go home via Siberia, and she couldn't understand when people tried to stop her. She didn't allow other people's negative opinions to sway her. She just told them she must, she must get to Siberia. As a result, there were many people who met her and remembered her, even years later, because of her drive to make it home.

She was adaptable. She adapted when she was arrested and jailed in Oakalla. She adapted when she was turned away at the US border in Hyder, Alaska. She adapted to staying in Dawson City for a whole winter, got a job and met people. She taught herself to maintain her boat, and then she steered it all the way down the Yukon River to its mouth.

Lillian knew how to improvise. By necessity, much of her trip was improvised. Some people have written that she had a plan, but Lillian would have had access to

comparatively few resources, aside from maps, and so left most of her itinerary to chance. She planned what she could and improvised when she was faced with unexpected or perilous situations in her travels.

During some phases of her journey, she would have been focussed entirely on survival. With no prior experience to guide her, she had to decide how to make it over the next mountain. How to cross a river without drowning. How, with limited English, to persuade someone to give her directions along a game trail. How to find food and water. How to stay warm and not die of exposure. How to overcome pain—such as that from bad shoes, sunburn, muscle or bone aches, severe bug bites, and intestinal discomfort from iffy water and food. We know these things about her because people remarked on them as she accomplished them. But what we don't know are the times in the wilderness when she was alone for weeks at a time, where she may have fallen or encountered predators like wolves, bears or cougars or where she had no food.

She had remarkable endurance. In a three-year cross-continent trek, there would have been a lot of things to fear. Wild animals. Dying of exposure. Getting lost in the wilderness. Strange people. Crossing bridgeless rivers. Freezing to death. Drowning. Yet she kept going.

Three years is a long time for any journey and would have required much patience. Of course, the times that would have required the most patience would have been the winters she spent in Vancouver and Dawson. When she arrived in Dawson, she had been wearing the same clothes for months; she had just travelled down an unknown (to her) river alone, and she was walking into a strange town with the knowledge she had to stay there for months. It must have been so difficult to stay in one place when she was eager to get back on the road. But while she would have had to exercise patience and restraint during times when it was impossible to travel, she would have needed a great deal of patience when travelling alone, taking her time to make careful decisions, never blundering ahead without thinking.

These character traits, which to some would seem too dogged, too rigid, or just plain crazy, not only kept Lillian going but also kept her alive in circumstances that would have killed lesser people. I think Lillian herself always believed that she would make it to the shores of Siberia, yet she was no dreamer. She was practical enough to know when to accept help from others and allowed people to give her food and clothing. She carried enough food for survival, yet she didn't overburden herself with luggage. She was not foolhardy or insane. She was prepared.

Lillian Alling's endurance was formidable and her bravery remarkable. Her personality and story resonate with strength more than eighty years later and touch our hearts. Who cannot identify with the desire to reach home in the face of great hardship? And this endurance is the reason I believe that she made it across Bering Strait and onto mainland Siberia.

I hope she made it home.

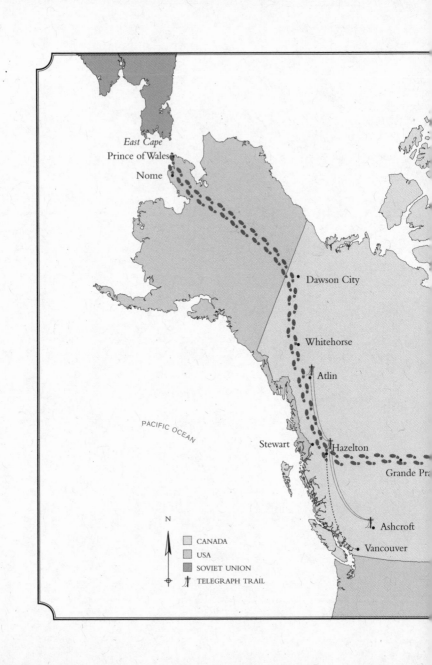

Journey Map

Sault Ste.
Marie

Winnipeg

Rochester

Niagara Falls

Acknowledgements

Without the assistance of librarians, museum staff and volunteers this book would not have been possible. The Quesnel Library's interlibrary loan service was so helpful in getting me the books I needed. The Stewart Museum gave me information that helped me to better understand the topography and geography of the area. The Hazelton Pioneer Museum and Archives sent me many useful items by mail, and Eve Hope was particularly helpful. The members of the Atlin Historical Society were terrific and also supplied some great photos, including some of the only known photos of Lillian in existence.

Peter Caffall-Davis of the Hyder Museum was very patient in explaining to me the transportation system in that area in the 1920s. The Yukon Archives were helpful in supplying archival images and information. Laura Mann

of the Dawson City Museum sent me their entire file on Lillian and some new photos of her as well, which was a wonderful surprise. They will be the recipients of my research files on Lillian Alling. The Carrie McLain Museum in Nome, Alaska, provided me with old news clippings from 1929, which proved invaluable.

Leslie Hamson of North Words Consulting was able to find some previously unknown information about Lillian by using the Yukon Archives. Elena of Blitz Information Russia was a great help in searching through Soviet newspapers. Siberian blogger and journalist Bolot Bochkarev was also of great assistance.

Lillian has been a passion and obsession for many people. Some have done their own research on her and collected documents and interviews but for their own reasons never put their thoughts into a book or an article. Instead, they generously shared their information with me. Alain Deschamps of Limoges, France, was extremely kind and sent all his Lillian research to me. Dietger Hollman mailed me a copy of his story on Lillian, which gave some new insight into her time in Atlin.

There were countless other local historians and interested folk who patiently answered my phone calls and emails with courtesy and enthusiasm. I thank them all very much.

Thank you to those people who read the manuscript in its early stages: Dan Davidson of Uffish Productions, Elizabeth Hunter of the Quesnel Museum, Jean Mackenzie, Bill Miller, Agnes Smith and Lorna Townsend. The line drawings were provided by Eric Josephy. Thank you, Eric.

Big thanks to editors Jane Stevenson and Betty Keller for their guidance. Thank you also to Vici Johnstone from Caitlin Press, who said "I'm interested" right from the start.

And the biggest thank you to Walter Josephy, for everything.

Endnotes

Chapter 1
The Mystery of Lillian Alling's Origins

1. Weatherford, Doris. *Foreign and Female: Immigrant women in America, 1840–1930.* New York: Facts on File, Inc., 1995, page 365.

2. Form 30, Canadian Immigration Service. Report of Admissions and Rejections at the Port of Niagara Falls, Ontario, for the month ending December 1926.

3. St. Stanislaus' Parish: the Heart of Toronto Polonia, in *Polyphony: Bulletin of the Multicultural History Society of Ontario: Poles in Ontario.* Fall/Winter 1984.

4. Email from Mary Munk, Canadian Genealogy Centre, Client Services Division, Library and Archives Canada.

5. Ancestry.com, Dictionary of Jewish Surnames in Russian Empire, downloaded March 24, 2008.

6. Email from Andrea D'Angelo, Processing Archivist, Archdiocese of Toronto, June 19, 2009.

7. Phone interview with Marc Lerman, Director of Archives, Archdiocese of Toronto, September 24, 2008.

8. Letter from Elizabeth Gray, Textual Archives Services Division, National Archives and Records Administration, May 18, 2010.

9. Pybus, Cassandra. *The Woman Who Walked to Russia*. Markham, Ontario: Thomas Allen & Son Ltd., 2002. First published in Australia as *Raven Road*. Cassandra Pybus, St. Lucia, Qld: University of Queensland Press, 2001.

10. Email from New York researcher Sandra Ceely.

11. State of New York, Department of Health, genealogy request reply received September 1, 2009.

12. Multicultural Canada website: Polish Migration and Arrival.

13. Weatherford. *Foreign and Female*, page 230.

14. Ibid., page 231.

15. "Woodcock Remembers Siberian Girl and Telegraph Trail," *Yellowhead / Stewart / Cassiar Times*, April 24, 1990.

16. Evans, Allen Roy. "The Girl Who Walked Home to Russia." *The Bedside Coronet*, Garden City, New York: Doubleday & Company, 1962, pages 19–24.

17. Ibid.

Chapter 2

Crossing Canada—Spring 1927

1. Cooper, Richard W. "Lonely Woman Headed Home the Hard Way," *Western People*, WP4, January 3, 1985.

2. Ibid.

3. Email correspondence from R.G. Harvey, April 22, 2008.

4. *Omineca Herald*, August 5, 1927.

5. "The Hottest on Record. Official Records for Fourteen Years Shows only 94 Degrees in 1917," *Omineca Herald*, August 4, 1927.

6. Duke, David Gordon. "Mystery surrounds the real Lillian Alling," *Vancouver Sun*, October 13, 2010.

Chapter 3

Fall and Winter 1927

1. *Omineca Herald*, August 27, 1927.

2. Miller, Bill. *Wires in the Wilderness*. Victoria: Heritage House, 2004, page 205.

3. "Woodcock Remembers Siberian Girl and Telegraph Trail," *Yellowhead / Stewart / Cassiar Times*, April 24, 1990.

4. He remained at Hazelton until January 1, 1929, when he was transferred to Smithers. He spent the years following in various provincial detachments, and in 1950, when the Provincial Police changed over to the RCMP, he was in Victoria at QuarterMaster Stores.

5. He was interviewed by Donald Stainsby for a *Van-*

couver Sun article that was published April 27, 1963. At that time, Wyman was an inspector for the BC Liquor Control Board. Stainsby, Donald. "She Walked 6,000 Miles to the Top of the World," *Vancouver Sun*, April 27, 1963. Wyman, quoted in Stainsby.

6. Wyman, quoted in Stainsby.

7. He died July 4, 1938, in Prince Rupert, two days after his forty-fifth birthday, from a gunshot wound from a .38 calibre revolver fired by American Mike Gurvich. Service had spent twenty-five years on the force.

8. Wyman, quoted in Stainsby.

9. Ibid.

10. Ibid.

11. Ibid.

12. Ibid.

13. Ibid.

14. Phone interview with Bill Kilpatrick, March 4, 2009.

15. Greenfield, T.E.E. *Drugs (Mostly)*. Meaford, Ontario: The Knight Press, 1976, page 11.

16. Telephone interview with Harley Greenfield of Meaford, Ontario, February 25, 2009.

17. Bennett, Martin L. "She Walked from New York to Russia," *True Magazine*, November 1941.

18. Wyman, quoted in Stainsby.

19. Greenfield. *Drugs (Mostly),* page 13.

20. Canadian Pacific Railway Company schedule for 1927, Alaska Service. Source: CP Archives.

21. Email from CP Archives, July 2, 2009.

22. Email from Kathleen Larking, Prince Rupert Public Library.

23. Letter received from Mac Culham, Manager, Corporate Information and Records, Royal BC Museum, February 24, 2009.

24. Andersen, Earl. *Hard Place to Do Time: The Story of Oakalla Prison: 1912–1991.* New Westminster: Hillpointe Publishing, 1993, page 46.

25. Koshevoy, Hymie. "More on Lillian Ailing," *Vancouver Province*, May 2, 1973; also follow-up letter from T.E. Greenfield.

26. Wyman, quoted in Stainsby.

27. Andersen. *Hard Place to Do Time*, page 13.

28. Ibid., page 28.

Chapter 4
Hyder, Alaska, to Smithers, BC

1. "The Gateway to the Mines of the Portland Canal District; the Mountain Anthracite Coal Fields and the

Logical Railway Outlet for the Peace River Valley."
Pamphlet issued by the Stewart Advancement League,
May 1928.

2. Potterton, L.A.N. *Northwest Assignment*. Kelowna,
BC: Mosaic Enterprises, 1972, page 9.

3. Peter Caffall-Davis, email correspondence, March
21, 2009.

4. Potterton, *Northwest Assignment*, page 10.

5. Ibid., page 9.

6. Excerpt provided October 2006 by Margaret
Vandenberg, Terrace, being a verbatim transcript from
an eight-page report by T.D. McLean to the Assistant
District Engineer, Department of Public Works, Prov-
ince of BC, file 2-20-0, submitted to the Prince Rupert
office on December 30, 1926. "Adopted 5 November
1953 on 104A, as identified on plans 14L23 and 16T293
[dates/titles not cited]." Source: BC place name cards, or
correspondence to/from BC's Chief Geographer or BC
Geographical Names Office.

7. Interview, George Simpson, September 2009,
author's files.

8. By "Telegraph Trail," we mean from Hazelton to
Atlin. By "Telegraph Line," we mean the entire line from
start to finish.

9. Email correspondence from Eric Hallam, president of the British Columbia Provincial Police Veterans Association, March 3, 2008.

10. Ladysmith newspaper obituary, courtesy of Ladysmith Archive.

11. Fairbairn was retired and living in Ladysmith on Vancouver Island when the interview took place.

12. Stainsby, Donald. "She Walked 6,000 Miles to the Top of the World," *Vancouver Sun*, Weekend Magazine, April 27, 1963.

13. *Omineca Herald*, June 20, 1928.

14. Stainsby. "She Walked 6,000 Miles."

Chapter 5

The Telegraph Trail

1. *Omineca Herald*, June 20, 1928.

2. Reed, Eleanor Stoy. "I Walked Empty Handed." Interview with Winfield Woolf, 1929. In the Reed Family Papers, Box #2, Archives, University of Alaska, Fairbanks.

3. Miller, Bill. *Wires in the Wilderness*. Victoria: Heritage House Publishing Company Ltd., 2004, page 213.

4. Stainsby, Donald. "She Walked 6,000 Miles to the Top Of The World," *Vancouver Sun*, April 27, 1963.

5. Reed. "I Walked Empty Handed."

6. Stainsby. "She Walked 6,000 Miles."

7. Reed. "I Walked Empty Handed."

8. Certificate of registration of death, Province of British Columbia.

9. Stainsby. "She Walked 6,000 Miles," pages 25 and 34.

10. This letter was on the same microfilm reel as Scotty's death certificate.

11. *Omineca Herald*, Wednesday, July 11, 1928. Although the newspaper reported that Scotty died on July 6, the official death record states he died on July 8.

12. Reed. "I Walked Empty Handed."

13. One account has Lillian saying, upon seeing the low river, "How could a man be so dumb as to drown in a dry creek?"—cited in Miller, *Wires in the Wilderness*, page 224. This was based on an interview with Eric Janze, nephew of Charlie Janze, who was quoting his uncle. Interview by Bill Miller, May 9, 2001.

14. Stainsby. "She Walked 6,000 Miles."

15. Smith, Diane Solie. "The Legend of Lillian Alling: The Woman Who Walked to Russia," Atlin Historical Society, 1997.

16. Stainsby. "She Walked 6,000 Miles."

17. Hoagland, Edward. *Notes from the Century: A journal from British Columbia.* Vancouver/Toronto: Douglas & McIntyre, 1969, page 223.

Chapter 6

Telegraph Creek to Atlin

1. Albee, Ruth and Bill. *Alaska Challenge.* London: Robert Hale Ltd., 1941, page 149.

2. Greenfield, T.E.E. Letter to the *Province* newspaper, May 2, 1973.

3. Albee and Albee. *Alaska Challenge*, page 140.

4. Hollmann, Dietger. "Mystery Woman—Der weite Weg der Liliane Alling." Unpublished manuscript (in German).

5. Smith, Diane Solie. "The Legend of Lillian Alling: The Woman Who Walked to Russia," Atlin Historical Society, 1997, page 11.

6. "Mystery Woman Reaches Dawson," the *Whitehorse Star*, October 19, 1928.

Chapter 7

Tagish to Whitehorse

1. Miller, Bill. *Wires in the Wilderness.* Victoria: Heritage House Publishing Company Ltd., 2004, page 137.

2. Reed, Eleanor Stoy. "I Walked Empty Handed." Interview with Winfield Woolf, 1929. In the Reed Family Papers, Box #2, Archives, University of Alaska, Fairbanks.

3. "Whitehorse Visited by Woman Hiker," the *Whitehorse Star*, August 31, 1928.

4. Not to be confused with the Tagish Post at Fort Sifton, which was farther south. Information on Ed Barrett, email correspondence with Albert James of Tagish, Yukon, and Leslie Hamson, North Words Consulting, April 28, 2010.

5. "Whitehorse Visited by Woman Hiker."

6. Hollmann, Dietger. "Der weite Weg der Liliane Alling." Unpublished manuscript (in German).

7. "Whitehorse Visited by Woman Hiker."

8. Ibid.

9. Gaffin, Jane. "John Olaf Erickson: Prospector and Hotelier." Unpublished article.

10. Leslie Hamson, phone interview with Goodie (Gudrun) Sparling, Whitehorse, April 26, 2009.

11. "Whitehorse Visited by Woman Hiker."

Chapter 8

The Road to Dawson

1. Coates, Ken S. and William R. Morrison. *Land of*

the Midnight Sun. Edmonton, AB: Hurtig Publishers Ltd., 1988, page 198.

2. Berton, Laura Beatrice. *I Married the Klondike*. Madeira Park, BC: Harbour Publishing, 2006, page 136. Originally published: McClelland & Stewart, 1961.

3. "Mystery Woman Reaches Dawson," the *Whitehorse Star*, October 19, 1928.

4. "The Mystery Woman," the *Whitehorse Star*, September 7, 1928.

5. Carmacks is named after George Washington Carmack. He and his brother-in-laws, Skookum Jim and Tagish Charlie, found the Discovery claim in 1896 while fishing on the Klondike River. Their discovery was the spark that kicked off the Klondike gold rush.

6. "The Mystery Woman."

7. "Mystery Woman Reaches Dawson."

8. "The Mystery Woman."

9. Frank, Jutta. *Abenteuer an Pelly und Yukon oder 6 Eier bis Dawson*. 2003 traveldiary.de, Reisliteratur-Verlag. Jens Freyler, Hamburg, page 61.

10. "Mystery Woman Reaches Dawson."

11. Coutts, R. *Yukon: Places and Names*. Sidney, British Columbia: Gray's Publishing, 1980, page 82.

12. Satterfield, Archie. *After the Gold Rush*. Philadelphia & New York: J.B. Lippincott Company, 1976, pages 11–12.

13. Yardley, Joyce. *Yukon Riverboat Days*. Hancock House Publishers Ltd., 1996, page 88.

14. Reed, J. Irving. "Did She Reach Siberia?" *Alaska Life*, June 1942.

15. "No Report of Mystery Woman," *Dawson News*, October 4, 1928.

16. "A Hazardous Trip: Walked Every Step of Way Hazelton to Stewart Crossing," *Dawson News*, October 6, 1928.

17. Ibid.

Chapter 9

Dawson City

1. "Mystery Woman Reaches Dawson," the *Whitehorse Star*, October 19, 1928.

2. "A Hazardous Trip: Walked Every Step of Way Hazelton to Stewart Crossing," *Dawson News*, October 6, 1928.

3. Gillespie, Archie. "The Girl Who Walked the Telegraph Trail," *Yukon News*, July 28, 1965.

4. Letter from Clifford Thompson to Candy Evans,

Research Librarian at the Dawson Museum and Historical Society, August 2, 1989.

5. Coates, Ken S. and William R. Morrison. *Land of the Midnight Sun.* Edmonton, AB: Hurtig Publishers Ltd., 1988, page 203.

6. Hutchison, Isobel Wylie. *North to the Rime-Ringed Sun. An Alaskan Journey.* New York: Hillman–Curl Inc., 1937, page 24.

7. Letter from Clifford Thompson to Candy Evans.

8. "A Hazardous Trip."

9. Ibid.

10. Gillespie. "The Girl Who Walked the Telegraph Trail."

11. Anglican Church, Diocese of Yukon fonds, Yukon Archives, Whitehorse COR 252 f. 11b.

12. Ibid.

13. Ibid.

14. Email correspondence, Lawrence Millman, January 13, 2011.

15. Millman, Lawrence. "Chasing Yukon's Mystery Woman," *Yukon News*, December 10, 2007.

16. Albee, Ruth and Bill. *Alaska Challenge.* London: Robert Hale Ltd., 1941, page 172.

17. Gillespie. "The Girl Who Walked the Telegraph Trail."

18. Berton, Laura Beatrice. *I Married the Klondike.* Madeira Park, BC: Harbour Publishing, 2006. Originally published: McClelland & Stewart, 1961.

19. Gillespie. "The Girl Who Walked the Telegraph Trail."

20. "Dawson's Mystery Woman Leaves for Down River," *Dawson News*, May 21, 1929.

Chapter 10

Floating Down to Nome

1. McCandless, Rob. "Sternwheelers, Steamboats, Paddlewheelers," *The Original Lost Whole Moose Catalogue,* 1979.

2. Hutchison, Isobel Wylie. *North to the Rime-Ringed Sun. An Alaskan Journey.* New York: Hillman-Curl Inc., 1937, page 61.

3. Ibid., pages 65–66.

4. Eley, Thom. "Sergeant William Yanert, Cartographer from Hell." In the *Geographical Review,* Vol. 92, 2002, page 1.

5. Hrdlicka, Ales, *Alaska Diary 1926–1931.* Lancaster, Pennsylvania: The Jaques Cattel Press, 1944, page 169.

6. Ibid.

7. Angus, Colin. *Beyond the Horizon.* Toronto: Doubleday Canada, 2007.

8. Hrdlicka. *Alaska Diary*, page 177.

9. Ales Hrdlicka papers, Box 169, Folder 2, labelled MJ9.56, National Anthropological Archives, Smithsonian Institution.

10. Angus. *Beyond the Horizon.* Colin Angus tells how ten days after leaving Dawson, they had gone 1,500 kilometres. Angus and Harvey, as was the point of their trip, used no mechanical propulsion, so their speed would have been similar to that of Lillian.

11. *Nome Nugget*, August 31, 1929.

12. Ira M. Rank was enumerated for the 1930 US census on October 2, 1929, just a month after Lillian left for Siberia. It showed he was male, white, single and born in Ohio, with both parents from Pennsylvania, and that he was a merchant. Ira Mahon Rank was listed on the 1920 census as being fifty-two years old, married and the proprietor of a grocery store.

13. Hunt, William R. *Arctic Passage.* New York: Charles Scribner's Sons, 1975, pages 188–189.

14. Hutchison. *North to the Rime-Ringed Sun*, page 83.

15. *Nome Nugget*, August 31, 1929.

16. Hrdlicka. *Alaska Diary*, page 252.

Chapter 11
The Final Walk

1. Hoyle, Gwyneth. *Flowers in the Snow: The Life of Isobel Wylie Hutchison*. Lincoln and London: University of Nebraska Press, 2001, page 110.

2. Hutchison, Isobel Wylie. *North to the Rime-Ringed Sun. An Alaskan Journey.* New York: Hillman-Curl Inc., 1937, page 100.

3. US Census 1930.

4. Albee, Ruth and Bill. *Alaska Challenge*. London: Robert Hale Ltd., 1941, pages 238–239.

5. Reed, J. Irving. "Did She Reach Siberia?" *Alaska Life*, June 1942.

6. Ibid.

7. Hunt, William R. *Arctic Passage*. New York: Charles Scribner's Sons, 1975, page 294.

8. Email correspondence, Blitz Information Russia, April 23, 2009.

9. Elmer E. Rasmuson & BioSciences Libraries University of Alaska, Fairbanks Rasmuson Library, online database.

Chapter 12

Prince of Wales to Siberia

1. Hrdlicka, Ales, *Alaska Diary 1926–1931*. Lancaster, Pennsylvania: The Jaques Cattel Press, 1944.

2. Albee, Ruth and Bill. "Don't Pity the Poor Eskimo," Part I, *Popular Mechanics*, November 1938, pages 137A and 139A.

3. Madsen, Charles, with John Scott Douglas. *Arctic Trader*. New York: Dodd, Mead & Company, 1957, pages 142–143.

4. Email correspondence. Blitz Information Russia, April 23, 2009, used finding-aids in the newspaper department of the Russian National Library. Other newspapers started their publications a few years later: *Sovetskaia Chukotka* [Soviet Chukotka], published in Anadyr since 1933; *Maiak Severa* [Lighthouse of North], published in Providenya since 1936; *Poliarnaia zvezda* [North Star], since 1938; *Magadanskaia Pravda* [Magadan Pravda], since 1935; and others, published in Pevek, Bilibino, Egvekinot, but at a later date.

5. Email correspondence. Blitz Information Russia, April 23, 2009. Newspaper issues examined: 1929: starting with No. 68, September 1, up to No. 99, December 29; 1930: No. 1, January 2, up to No. 75, September 27.

6. Perdue, Edward M. Lost Adventures: *From Wango to Solovetski Island* with John Williams Adkins, Westboro, MA, Curry Printing, 2004.

7. Burr, Martin. *In Bolshevik Sibera: The Land of Ice and Exile.* London: H.F. & G. Witherby, 1931, page 20.

8. Elmore, Arthur F. Letter to the editor, *True West* magazine. Cited in Francis Dickie, "New York–Siberia: The Astonishing Hike of Lillian Alling" in *Pioneer Days of British Columbia*, by Art Downs. Victoria: Heritage House, 1975, page 145.

Epilogue

1. "A Hazardous Trip: Walked Every Step of Way Hazelton to Stewart Crossing," *Dawson News*, October 6, 1928.

Selected Bibliography

Books, Articles and Pamphlets

Albee, Ruth and Bill. *Alaska Challenge*. London: Robert Hale Ltd., 1941.

———. "Don't Pity the Poor Eskimo," Part I & II, *Popular Mechanics*, November 1938.

Andersen, Earl. *Hard Place to Do Time: The Story of Oakalla Prison: 1912–1991*. New Westminster: Hillpointe Publishing, 1993.

Angus, Colin. *Beyond the Horizon*. Toronto: Doubleday Canada, a division of Random House of Canada Ltd., 2007.

Bennett, Martin L. "She Walked from New York to Russia." *True* magazine, November 1941.

Berton, Laura Beatrice. *I Married the Klondike*. Madeira Park, BC: Harbour Publishing, 2006. Originally published: McClelland & Stewart, 1961.

Bride, W.W. "Lone Adventuress," *The Beaver*, September 1943.

Burr, Martin. *In Bolshevik Sibera: The land of ice and exile*. London: H.F. & G. Witherby, 1931.

Coates, Ken S. and William R. Morrison. *Land of the*

Midnight Sun. Edmonton, AB: Hurtig Publishers Ltd., 1988.

Cooper, Richard W. "Lonely Woman Headed Home the Hard Way," *Western People*, WP4, January 3, 1985.

Coutts, R. *Yukon: Places and Names*. Sydney, British Columbia: Gray's Publishing, 1980.

Dickie, Francis. "Mysterious Lillian: Human Homing Pigeon." *True West* magazine, April 1972.

————. "New York–Siberia: The Astonishing Hike of Lillian Alling" in *Pioneer Days of British Columbia*, by Art Downs. Victoria: Heritage House, 1975

Duke, David Gordon, "Mystery surrounds the real Lillian Alling," *Vancouver Sun*, October 13, 2010.

Eley, Thom. "Sergeant William Yanert, Cartographer from Hell." In the *Geographical Review*, Vol. 92, 2002.

Greenfield, T.E.E. *Drugs (Mostly)*. Meaford, Ontario: The Knight Press, 1976.

Hoagland, Edward. *Notes from the Century Before: A journal from British Columbia*. Vancouver/Toronto: Douglas & McIntyre, 1969.

Hoyle, Gwyneth. *Flowers in the Snow: The Life of Isobel Wylie Hutchison*. Lincoln and London: University of Nebraska Press, 2001.

Hrdlicka, Ales. *Alaska Diary 1926–1931*. Lancaster Pennsylvania: The Jaques Cattel Press, 1944.

Hunt, William R. *Arctic Passage*. New York: Charles Scribner's Sons, 1975.

Hutchison, Isobel Wylie. *North to the Rime-Ringed Sun: An Alaskan Journey*. New York: Hillman-Curl Inc., 1937.

Jutta, Frank. *Abenteuer an Pelly und Yukon oder 6 Eier bis Dawson*. 2003 traveldiary.de, Reisliteratur-Verlag. Jens Freyler, Hamburg.

Koshevoy, Hymie. "More on Lillian Ailing," the *Province*, May 2, 1973.

Lebedev, V.V. "Siberian Peoples: A Soviet View" in *Crossroads of Continents: Cultures of Siberia and Alaska*. William W. Fitzhugh, Aron Crowell, eds. Washington, DC: Smithsonian Institution Press, 1988.

Madsen, Charles, with John Scott Douglas. *Arctic Trader*. New York: Dodd, Mead & Company, 1957.

Miller, Bill. *Wires in the Wilderness*. Victoria: Heritage House Publishing Company Ltd., 2004.

Millman, Lawrence. "Chasing Yukon's Mystery Woman." *Yukon News*, December 10, 2007.

Perdue, Edward M. *Lost Adventures From Wango to Solovetski Island with John William Adkins*: Westboro,

MA, Curry Printing, 2004.

Potterton, L.A.N. *Northwest Assignment*. Kelowna, BC: Mosaic Enterprises, Finlay Printing, 1972.

Pybus, Cassandra. *The Woman Who Walked to Russia*. Markham, Ontario: Thomas Allen & Son Ltd., 2002. First published in Australia as *Raven Road*. Cassandra Pybus. St. Lucia, Qld: University of Queensland Press, 2001.

Reed, J. Irving. "Did She Reach Siberia?" *Alaska Life*, June 1942.

Satterfield, Archie. *After the Gold Rush*. Philadelphia & New York: J.B. Lippincott Company, 1976.

Stainsby, Donald. "She Walked 6,000 Miles to the Top of the World." Weekend Magazine, No. 17, *Vancouver Sun,* April 27, 1963.

Stewart Advancement League pamphlet. "The Gateway to the Mines of the Portland Canal District; the Mountain Anthracite Coal Fields and the Logical Railway Outlet for the Peace River Valley," May 1928.

Weatherford, Doris. *Foreign and Female: Immigrant women in America, 1840–1930*. New York: Facts on File, Inc., 1995.

Yardley, Joyce. *Yukon Riverboat Days*. Surrey, BC: Hancock House Publishers Ltd., 1996.

Yellowhead/Stewart/Cassiar Times. "Woodcock Remembers Siberian Girl and Telegraph Trail," April 24, 1990.

Newspapers

Omineca Herald, 1927–1928

The *Whitehorse Star,* 1928

Dawson News, 1928–1929

The *Province,* Vancouver 1973

Yukon News, 1965

Nome Nugget, 1929

Archives and Libraries

Archdiocese of Toronto

Atlin Historical Society

CP Archives

Dawson City Museum

GIC MVD [Main Information Centre of the Ministry of Interior Affairs], Russian Federation

Hazelton Pioneer Museum & Archives

Hyder Museum

Ladysmith Archive

Library Archives Canada

National Archives and Records Administration

Prince Rupert Public Library

Quesnel Branch of the Cariboo Regional District Library

Royal BC Museum

Smithsonian Institution, National Anthropological Archives

Stewart Museum

University of Alaska, Fairbanks

Vancouver Public Library

Yukon Archives

Papers and Manuscripts

Gaffin, Jane. "John Olaf Erickson: Prospector and Hotelier." Unpublished article.

Hollmann, Dietger. "Mystery Woman—Der weite Weg der Liliane Alling." Unpublished manuscript (in German).

Smith, Diane Solie. "The Legend of Lillian Alling: The Woman Who Walked to Russia," Atlin Historical Society, 1997.

Whitehouse, Ed. "The Woman Who Walked to Nowhere." Unpublished manuscript.

Susan Smith-Josephy is a writer, researcher and genealogist. She trained as a journalist at Langara College and has worked for a number of small-town newspapers in BC. She has a degree in history from SFU, and is passionate about BC history. She lives in Quesnel, British Columbia. *Lillian Alling: The Journey Home* is her first book.